Siriol Sherlock

BOTANICAL ILLUSTRATION

Painting with watercolours

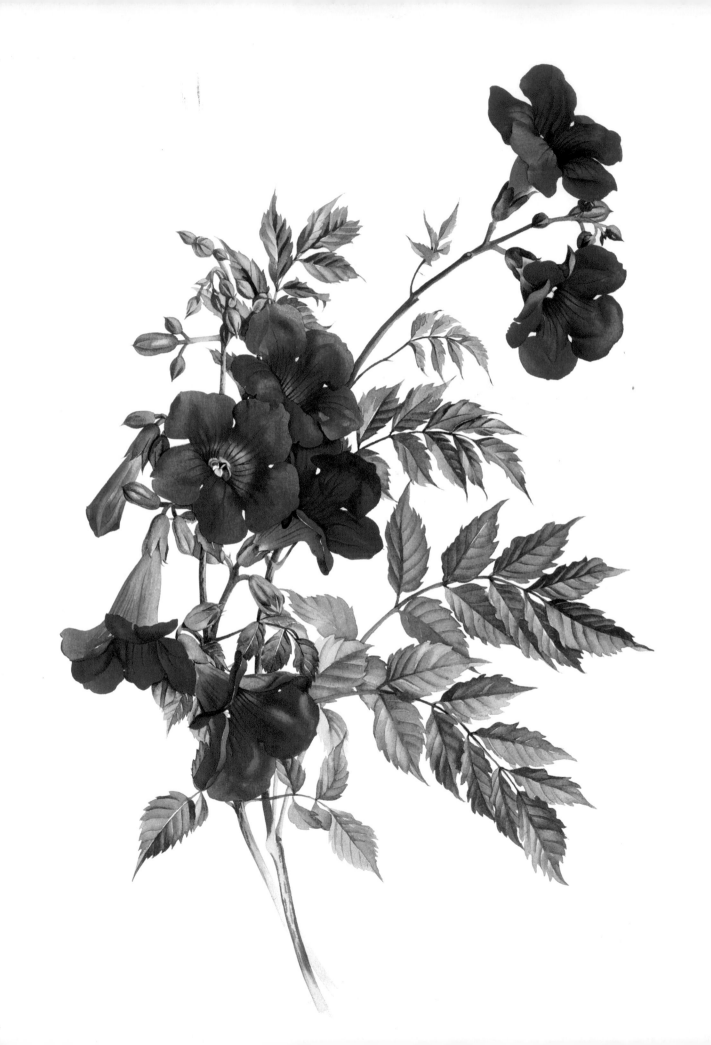

Siriol Sherlock

BOTANICAL ILLUSTRATION

Painting with watercolours

B T BATSFORD

To Joan and Sandy

Acknowledgements
I would like to thank the editorial and design staff at B T
Batsford – we got there in the end! Also the picture librarians
at the Kew Library and the Lindley Library.

Painting on page 2: *Campsis* × *tagliabuana* 'Madame Galen'

First published 2004
Reprinted 2004

0 7134 8862 X

A CIP record for this book is available
from the British Library.

Printed in Malaysia

for the publishers

B T Batsford
The Chrysalis Building
Bramley Road
London W10 6SP

An imprint of Chrysalis Books Group plc

Distributed in the United States and Canada by
Sterling Publishing Co.,
387 Park Avenue South, New York, NY 10016, USA

Contents

Introduction

Botanical artists have different priorities. Some relish the challenge of painting every microscopic detail to absolute perfection, showing every vein on a leaf and meticulously painting every stamen in a flower. For others, capturing the beauty and character of the plant in a slightly more relaxed manner is more important. The meticulously detailed study and the slightly looser representation will both look like the real thing if beautifully and skilfully executed and both may fulfil the requirements of the illustration, whether it be for identification purposes (as in a horticultural reference book) or simply to stand out on a wall in a house or gallery.

The ability to be flexible is most useful to the botanical artist. We don't all have the time, inclination or patience to do incredibly detailed work and, unless it is formed by the most skilful of artists, there is a danger of it looking sterile and overworked, whereas slightly looser, fresher watercolour often captures the character and essence of a plant much better. It also fulfils the requirements of both beauty and realism by using and retaining the freshness and translucency of watercolour – the perfect medium for botanical subjects.

Imagine a single rose petal. Some botanical artists would build up that petal with hundreds of tiny, delicate brushstrokes, overlaying more and more strokes to build up the deepest colours and tones; some would form the petal with many layers of pale washes or 'glazes', overlaying more and more washes to attain the deepest colours and tones. These techniques can be used to produce stunning botanical paintings but for those of us who have neither the time nor the patience, there is another way, albeit a more risky way until you learn through experience how to handle watercolour and know how it is likely to behave – though even now it still amazes, delights or confounds me at times!

Watercolour painting cannot be an exact science; there can be no precise formulas for guaranteed success. If there were exact formulas, all artists' work would look the same, which would be incredibly boring. Fortunately there are far too many unknowns that will affect the outcome: the warmth of the air; variation in light; subtle differences in papers, brushes and colours; the amount of water used; the dexterity of the artist's hand, the ability to observe and to convey from eye to hand – not to mention differences in mood and confidence of each artist from day to day, which influence the outcome enormously.

I am often asked, 'Do you need to be inspired to paint well?' Yes, inspiration plays a huge part in the success of a painting and it is usually a mistake to force yourself to paint when you are feeling uninspired but sometimes you have to, especially if you are trying to make a living. This book should help you to master the skills and give you the confidence you need to achieve good results whether inspired or not – and if it inspires you as well, that is a real bonus!

Here lies the secret: economy of layers and brushstrokes and therefore economy of time and labour. This is achieved by getting as much variation as you can into one layer of watercolour by using and controlling the natural inclination of watery paints to run and blend into one another or into clear water on the paper – wet into wet. If this first wet-in-wet layer is done well, it should replace the many glazes or tiny brushstrokes of other methods and there will be little more work to do; and yet very fine detail can still be added to finish the painting without overworking and losing the wonderful freshness and translucency of watercolour.

It should be simple: some artists take to it like a duck to water – and knowing how to handle water is vital in watercolour painting! Some relish the security of being tight and controlled and find it very hard to let go of their inhibitions and take a risk. Many need the safety net of a detailed drawing before the merest touch of colour ever leaves their paintbrush to stain that pristine sheet of watercolour paper. I prefer not to draw the plant in pencil first so I am free to move the paint around on the paper – to mould and blend it without the restriction of pencil lines which, as plants are always moving, are anyway usually in the wrong place by the time you come to paint.

Something for everyone

- If you are interested in botany you will probably want to approach painting plants from a scientific angle; measuring, counting and magnifying to see every minute detail. I would urge you, however, to try out the wet-in-wet technique; you can learn to use it with great accuracy and detail. This book will not, however, give you in-depth tuition on scientific analysis, botanical line drawing, using microscopes and so on – there are many experts far more knowledgeable than I who can teach this.

- If you are new to watercolour painting, this technique is a great way to experience the delights of the medium.

- You may already possess drawing, design or colour skills but need help with handling watercolour.

- You may be an experienced watercolourist who is strong on technique but needs help to attain the accuracy, detail and realism needed to paint identifiable plants.

- Maybe you have tried other techniques like those mentioned above and found that you do not have the time or patience to continue painting this way and need help to speed up and loosen up.

- Then there are those of you who don't have the time or the inclination to paint flowers but may be curious to see how a realistic image can emerge from a flat sheet of paper. Or perhaps you just enjoy looking at botanical paintings. Without you there would be little point in our painting; how could we continue if nobody bought our work or encouraged us to carry on to greater heights?

I hope you all enjoy this book.

Siriol Sherlock

Note: Unless specified, all the illustrations were painted by the author, in watercolour on paper, and are in private collections.

Right: *Fritillaria meleagris*
(Snake's Head Fritillary)

1 THE BOTANICAL ARTIST

For centuries artists have endeavoured to paint much of the plant life of our planet. Many precious plants have undoubtedly been lost before they were even discovered, so no artist or photographer had the chance to record them for posterity. In fulfilling a creative urge to record images of plants, botanical artists and illustrators have given pleasure and enlightenment to those who view their work: for some, the herbal, medicinal, botanical, horticultural or scientific value of such illustrations was of paramount importance. They have added significantly to society and civilization.

Flower painter, botanical artist or botanical illustrator?

These three categories of one form of art have evolved side by side throughout history and into the 21st century. Everyone likes a label or classification, so there is no confusion between supposedly different disciplines used to fulfil different objectives – a label makes it easy to explain who you are. However, the naturalistic portrayal of plants can fit into all three slots, as this book aims to demonstrate, and the boundaries are often blurred.

My artistic career has been through many different phases – textile designer, portrait painter, house painter (pictures of … not a decorator!), flower painter, landscape painter, botanical artist, illustrator, teacher – and I hope it continues to evolve. For the last 18 years I have worked predominantly with one of my first loves – plants – and concentrated on painting them in the medium I love best and feel most confident with – watercolour. Therefore, in recent years, I have assumed the title of 'botanical artist'; my paintings of plants encompass all three categories and, as this title covers the middle ground, this seems to keep everyone happy. It is the diversity, beauty, colour, shape and texture of plants that attracts my interest as an artist rather than the science and botany. Any botanical and horticultural knowledge that has supplemented my very basic school botany has come simply from careful observation of the plants both when painting them and from growing them in my garden. I therefore tend to leave scientific, analytical illustration to the experts, only occasionally using magnification and cross sections to show the structure and beauty of different parts of a plant. But, by painting what I see through close observation (rarely with a magnifying glass), my work is, I hope, always true to life.

Sometimes the beauty of a plant is in its detail, such as the chequerboard pattern on a Snake's Head Fritillary (page 7), and the artist must endeavour to portray this as accurately as possible. Where the detail is less important, I try to convey the character, habit, colour and texture of the plant, so that it looks real and alive, rather than laboriously painting every single hair, vein or stamen, which can produce a very stiff, overworked and lifeless image with superfluous detail – detail that is not needed to create a realistic, identifiable, living image. *Strelitzia nicolai* (right) could have been painted laboriously, with every tiny detail included, but the quick and lively use of watercolour probably reflects its remarkable character much better. Capturing these characteristics was the priority for many of the great masters of botanical art; while examining the wonderful, original paintings of several of these talented and highly skilled artists, I have discovered that many of them used very similar painting techniques to my own.

Right: Strelizia nicolai

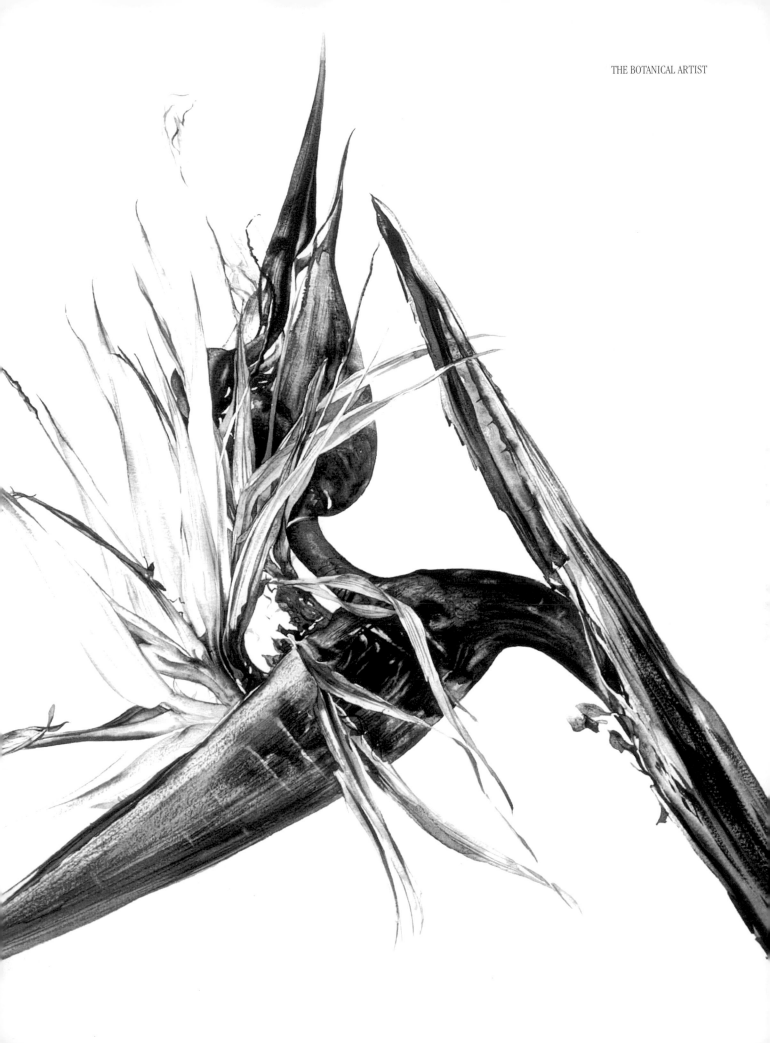

The development of botanical art

Some of the earliest botanical illustrations ever found are the depictions of 275 Syrian plants chiselled in stone relief (c. 1450 BC) in the Great Temple of Tuthmosis III at Karnak in Egypt; many of the plants are quite recognizable. Plant forms were also used decoratively on ancient pottery and frescoes. But it was their medicinal and herbal use that led to the creation of the great herbals with their plant illustrations. One of the oldest is the Codex of Dioscorides *(Codex Vindobonensis)* which is a wonderful manuscript created for Juliana Anicia (the daughter of Flavius Anicius Olybrius, Emperor of the West) around AD 512. It includes nearly 400 paintings of plants, many of which were probably copied from earlier illustrations of the first and second centuries AD (which unfortunately have not survived), notably those by the physician Krateuas. The manuscript includes his writings and those of the great medicinal plant expert, Dioscorides.

The illustrations in these very early manuscripts were quite realistic but unfortunately they were copied and recopied throughout the centuries and often ended up looking ridiculous as the illustrators did not take the trouble to re-examine real plants. Throughout the Middle Ages plants were put to medicinal and herbal use and not really cultivated for their beauty, so drawings showing the basic characteristics of flowers, leaves, fruits and roots (which were often the part used), together with written descriptions of the plants and their uses, were thought adequate. Many regrettable mistakes must have been made by wrongly identifying plants from these highly stylized images.

In the 15th and early 16th centuries, Renaissance artists, such as Leonardo da Vinci (1452–1519) in Italy and Albrecht Dürer (1471–1528) in Germany, carefully studied living plants (as well as numerous other subjects) and began to depict them realistically. They were among the first of the modern, naturalistic, botanical artists. Leonardo used a variety of media including red chalk and pen and ink for his bold and vigorous plant drawings, which captured the character, form and natural habit of the plants beautifully. Dürer advised artists to 'study nature diligently. Be guided by nature and do not depart from it, thinking you can do better yourself. You will be misguided, for truly art is hidden in nature and he who can draw it out possesses it.' He occasionally used watercolour to paint exquisite studies of wild plants in their natural habitat such as *Das grösse Rasenstück* (Great Piece of Turf), a beautifully observed and detailed, ecological study of a patch of common wild plants including grasses, dandelions, daisies, speedwell and plantains. This painting proves that we do not need spectacular or exotic subjects to make a beautiful picture – even common 'weeds' can be beautiful.

With the introduction of the woodcut to Europe in the 15th century, the first printed herbals were produced. It became possible to copy the original artists' illustrations more accurately and print them as line drawings. These were rather crude at first but later the craftsmen who prepared the woodcuts and wood

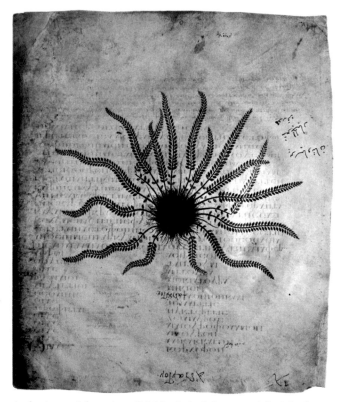

Asplenium trichomanes (Maidenhair Spleenwort) [original illustration named *Adianton*] from the *Codex of Dioscorides*. Bildarchiv d. ÖNB, Vienna.

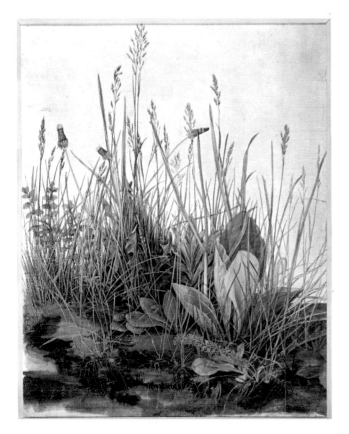

Das grösse Rasenstück (Great Piece of Turf).
Albrecht Dürer. Watercolour and body colour, 1503.
Graphische Sammlung Albertina, Vienna, Austria/Bridgeman
Art Library.

engravings became highly skilled artists in their own
right, able to produce finely detailed, three-
dimensional images which were sometimes hand-
coloured, often rather clumsily, as in the woodcut of
Hans Weiditz's *Symphytum officinale* (right). Otto
Brunfels and Leonhart Fuchs published two of the best
and most realistic herbals in the 16th century but they
could never re-create in print the delicate gradation of
tones and hues, the translucent effects and the realism
that artists such as Hans Weiditz (Johannes Guidictius,
c. 1500–1536) were then achieving in watercolour. His
original paintings were interpreted as wood engravings
for Brunfel's *Herbarum Vivae Eicones* (Living Portraits
of Plants). In Italy, Giacomo (Jacopo) Ligozzi
(1547–1626), who later became Superintendent of the

Uffizi Gallery, Florence, was also leading the way by
painting beautiful, realistic plant portraits.

Etching and engraving on metal plates were soon to
replace woodcuts for the printing of herbal and
botanical books. By the 17th century, when the great
French artists, Nicolas Robert (1614–85) and Claude
Aubriet (1665–1742) were painting, skilled craftsmen
were able to create very refined shaded effects, which
came even closer to the subtleties of the artists'
original paintings. Robert became a highly skilled
engraver as well as a wonderful painter. During the
second half of the 16th century the appreciation of

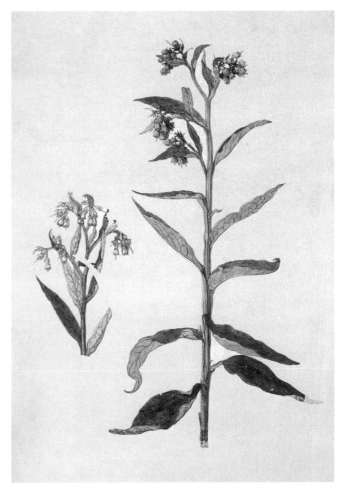

Symphytum officinale. Hans Weiditz. Watercolour, 1529.
Copyright University of Berne.

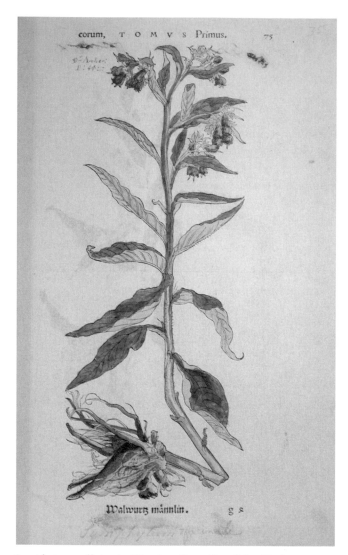

Symphytum officinale. Woodcut from Brunfels, *Herbarum Vivae Eicones,* 1530. Copyright Royal Botanic Gardens, Kew.

hybrids that the horticulturalists developed from these new species. It was only in the 20th century with the introduction of colour photography that the artists' skills became dispensable; but even now, in the 21st century, photography cannot be relied upon – especially where accurate colour and detail is concerned.

Other artists, particularly those of the Dutch and Flemish schools such as Willem van Aelst (1627–83), Rachel Ruysch (1664–1750), a rare woman in this man's world of botanical illustration, and Jan van Huysum (1682–1749) chose to paint fabulous masterpieces displaying the sheer extravagance of the flora and fauna that was now accessible. They often used watercolour for sketches but their finished pieces were usually in oils.

Echinophora spinosa. Giacomo Ligozzi. Gabinetto disegni e stampe degli Uffizi, Florence, with the permission of Ministero dei Beni e le Attività Culturali.

flowers for their variety and beauty, rather than their medicinal properties, flourished and European interest in horticulture exploded. Medieval medicinal and herbal gardens were replaced by fabulous flower gardens. Thousands of new forms and colours of native European flowers were created and new species were added from the Near East, the New World and Africa. Rich patrons wanted original colour paintings of their plants and commissioned many large florilegia (books of flower paintings). From the 16th to the 20th century the botanical artists of Europe were inundated with commissions to paint new specimens brought back by the great plant hunters from abroad, or even to travel with them to record the indigenous flora and fauna. There was also a profusion of new varieties and

Techniques of some great botanical artists

With this great explosion of horticulture, botanical artists needed to work speedily and yet capture with accuracy and realism the shapes, details, colours, characters and habits of all these exciting new plants. Their illustrations had to be realistic so they could be used for reliable reference by botanists and horticulturalists. These dedicated artists produced wonderful collections of paintings, many of which are now in the safekeeping of great institutions such as the Lindley Library at the Royal Horticultural Society in London and the Royal Botanic Gardens at Kew. From this heyday of botanical art I have chosen examples from just a few artists, most of whom worked with watercolour using techniques similar to my own.

Georg Dionysius Ehret (1708-70)

One of the best and most prolific botanical artists who, though born in Germany, spent much of his working life in England. Many of his finished paintings were completed with body colour (opaque watercolour or 'gouache') on vellum. This style worked well when copied in the fine engravings of the time, many of which were then in colour and often engraved by Ehret himself. His sketchbooks (in the Natural History Museum) reveal a lively, spontaneous and deft touch that was slightly lost in the finished paintings. Like many botanical artists, he was often forced to work from quick sketches, colour notes and dried specimens, and it is difficult to recapture that original freshness when you have to produce the finished piece in this way rather than painting directly from life – it takes great skill to make it work.

In *Stuartia malacodendron* (right), as in many of his paintings, he has combined his transparent watercolour technique and his smoothly blended, opaque technique. For the translucent flowers he made use of the creamy-white colour of the vellum as the main flower colour, softly blending pale grey washes to give the petals form; delicate, fine lines were used to finish them off. For the leaves, body colour was smoothly blended to gradate the hues and tones and create a rather graphic and slightly stylized image; to mix the lighter shades and give the leaves his typical, bluish sheen, more white paint was mixed with colour. He had a natural talent for design, and the plant is gracefully placed on the page yet still looks natural.

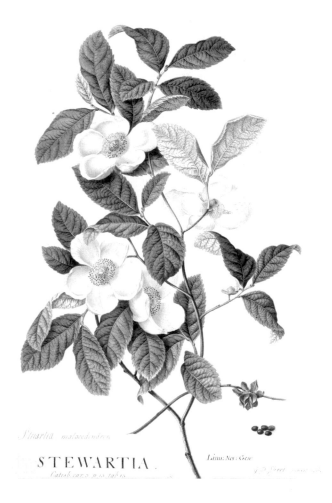

Stuartia malacodendron.
Georg Dionysius Ehret. Watercolour and body colour on vellum, 1764. Copyright Royal Botanic Gardens, Kew.

Pierre-Joseph (1759–1840) & Henri-Joseph Redouté (1766–1857)

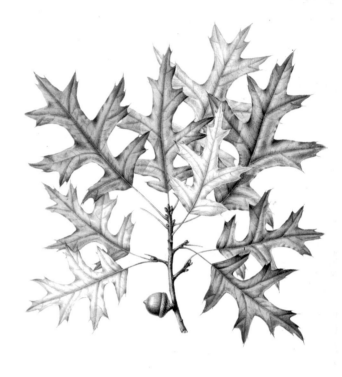

One of three Belgian-born artist brothers, Pierre-Joseph Redouté worked in France for many illustrious patrons including Marie-Antoinette and Josephine Bonaparte. He was, in his time, the most famous botanical artist – and probably still is. It is likely that he learnt his particular technique of botanical watercolour painting from the artist and teacher Gerard van Spaëndonck (1746–1822), as did his lesser-known but equally talented younger brother, Henri-Joseph. Van Spaëndonck had changed from gouache to watercolour in 1784, and the Redoutés went on to develop his watercolour techniques to the utmost perfection. No words can describe the stunning original watercolours better than Wilfrid Blunt in *The Art of Botanical Illustration*: 'Pure watercolour, gradated with infinite subtlety and very occasionally touched with body-colour to suggest sheen….'

Among numerous works, the two brothers painted monochrome illustrations for *Histoire des Chênes de l'Amerique* (*The Oaks of America*, 1801) by André Michaux. Henri-Joseph's illustration of *Quercus palustris* (above right) exhibits these perfect, translucent, gradated washes which give an exquisite sheen to the leaves. Indeed, his illustrations for this book are even finer than his brother's. These paintings were skilfully copied by engravers so they could be printed in the book (below right). Much of Pierre-Joseph's work was reproduced by colour-printed stipple engraving and it is from these that we know it so well. These interpretations were very fine and came closer to the original watercolours than any previous printing technique.

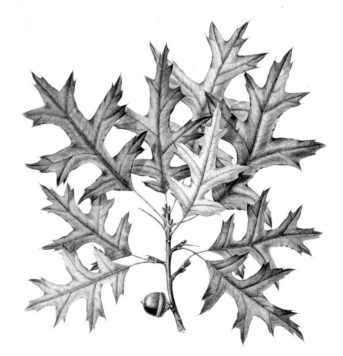

Quercus palustris. Henri-Joseph Redouté. Ink wash on paper, original for *Histoire des Chênes de l'Amerique*. Copyright Royal Botanic Gardens, Kew. (top right)

Quercus palustris. Henri-Joseph Redouté. Engraving by Pleé for *Histoire des Chênes de l'Amerique*. Copyright Royal Botanic Gardens, Kew. (bottom right)

Ferdinand (1756–1826) and Francis (Franz) Bauer (1758–1840)

These brothers from Lower Austria were prolific artists who worked mostly for British patrons such as Sir Joseph Banks. Francis lived and worked at Kew from 1790, while Ferdinand travelled widely as a botanical artist on intrepid explorations such as the five-year voyage to Australia led by Matthew Flinders in 1800. Many of their original paintings were copied by lithography, which had replaced engraving and produced excellent, almost photographic, prints.

The brothers never shrank from tackling the most difficult of subjects. Ferdinand's painting of *Digitalis laevigata* (above right) is just one of many tricky foxgloves he painted. He has drawn the finest, almost invisible, outline and the fine hairs. For the flowers, he made use of the creamy-white paper for the palest tones, adding no white body colour. Their bulbous shapes were formed by a delicate blending of translucent watercolour laid down with the lightest of touches; in the large, opened-up flower detail, the colour has been skilfully blended away to nothing and a tiny touch of softened grey finishes the curving, white lip. The tiny markings on the inside of the flowers have been quickly and deftly dotted in and vaguely indicated where they show through the translucent trumpets. There are lovely strong contrasts in the leaf colours and it looks as though the large leaf on the left was finished off with dry-brush or stippling to give it a felty texture.

Digitalis laevigata. Ferdinand Bauer. Watercolour. Lindley Library, Royal Horicultural Society. (right)

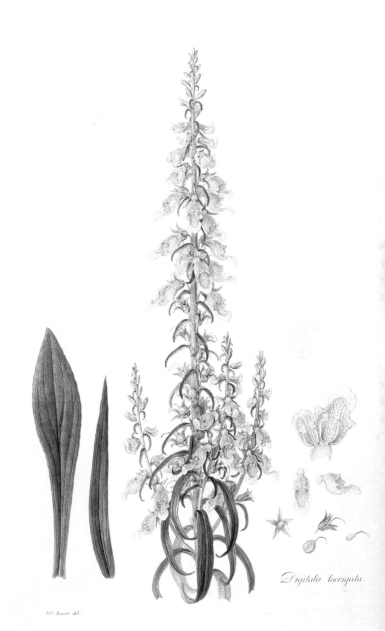

Digitalis laevigata

Walter Hood Fitch (1817–92)

While working as a calico designer in Glasgow, Walter Hood Fitch's talents were soon discovered by Sir William Hooker who became Director of the Royal Botanic Gardens at Kew. Fitch worked for both Sir William and his son Sir Joseph for over forty years and was for many years the sole artist for *Curtis's Botanical Magazine*, founded in 1787 and still published by Kew to this day (now called *The Kew Magazine*). He was a real virtuoso and must have been a fast worker as he was unbelievably prolific. The main purpose of his paintings was to record enough information to make the finished plates for printing and to aid the colourists who washed in the colours on the published prints for the magazine.

He was his own lithographer, publishing thousands of plates in books and periodicals. Copying from his watercolour sketches and drawings, he would draw directly onto a certain type of stone with a special, greasy ink. The stone was then wetted before more greasy ink was rolled over it. This was resisted by the wet areas and therefore only the drawn areas would print onto paper when it was pressed against the stone. With this method of printing, Fitch was able to interpret the soft gradations of tone he achieved in his watercolours.

The thought of painting *Saxifraga florulenta* (right), with its rosettes made up of hundreds of small leaves, would induce fear in most botanical artists but Fitch would tackle any subject and paint it with sheer virtuosity. The plant has been deftly but freely sketched in pencil, then watery colour quickly washed in and touches of darker tones overlaid to build contrast and give the plant form. He has captured its character and all the important details in this apparently effortless style.

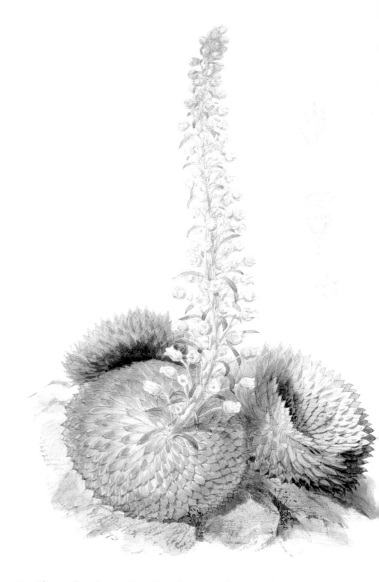

Saxifraga florulenta. Pencil and watercolour. Walter Hood Fitch. Copyright Royal Botanic Gardens, Kew.

Frank Harold Round (1878–1958)

While working as Assistant Drawing Master at Charterhouse, Frank Harold Round painted many wonderful Iris studies for the Hon. N C Rothschild and for W R Dykes (reproduced rather badly in *The Genus Iris*, 1913). All botanical artists will be able to sympathize with his practical problems when he wrote, 'The drawings for Dykes were easy and comfortable to do; he was a nearby colleague, so he handed me plants at our mutual convenience. But Rothschild's came by post, often three or four at a time. As I was teaching most of the day, it was a hectic rush. Often I had to start with the closed buds of several plants, and then make use of them again, when they opened, to replace the blooms at the top which had meanwhile died.'

He must have worked very intensively and speedily during the short Iris season – perhaps that is why the paintings have a wonderful liveliness and simplicity. He simply didn't have time to overwork his paintings by adding superfluous detail, yet they include all that is necessary for identification. He admitted he knew nothing about Irises but simply made 'clear, descriptive drawings as though for a catalogue'.

In *Iris foliosa* (right), he used the minimum of line drawing before vigorously washing in the watercolour. The flowing curves of the long, flat leaves have been painted with amazing confidence, blending light and darker tones of fluid, effortless watercolour, wet in wet. The stem is delightfully simple, with the paper shining through to make it look tubular. The fresh, lively blending of translucent watercolour captures the smooth, silky character of the petals perfectly, because it has not been overworked. Markings on the petals show just enough detail, without over-complicating, and are identifiable in every one of the many Irises he painted.

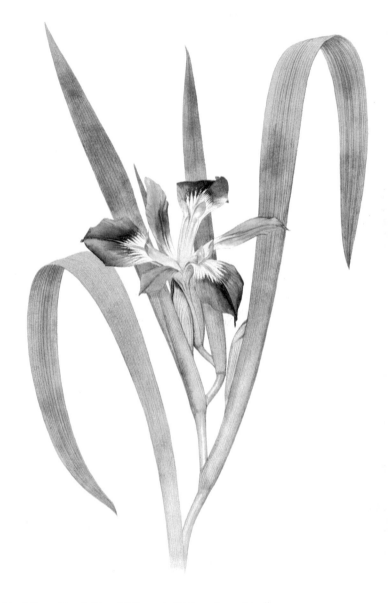

Iris foliosa. Frank Harold Round. Watercolour. Lindley Library, Royal Horticultural Society.

The twentieth century

Many of the dedicated and prolific botanical artists of the 20th century worked with or for the Royal Botanic Gardens at Kew. It is especially the women, such as Lilian Snelling, Stella Ross-Craig, Margaret Mee and Mary Grierson, who became real experts at handling watercolour.

Paeonia bakerii. (right)
Lilian Snelling. Watercolour, 1931. Lindley Library, Royal Horticultural Society.

Doryanthes palmeri. (below)
Mary Grierson. Watercolour, 1966. Copyright Royal Botanic Gardens, Kew.

Gustavia augusta. (bottom right)
Margaret Mee. Watercolour, 1985. Copyright Royal Botanic Gardens, Kew.

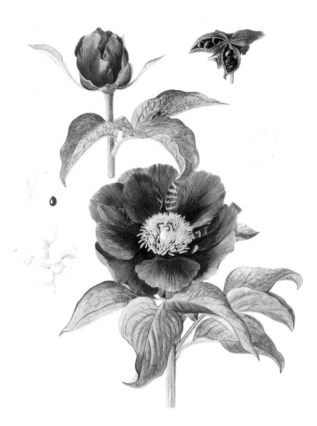

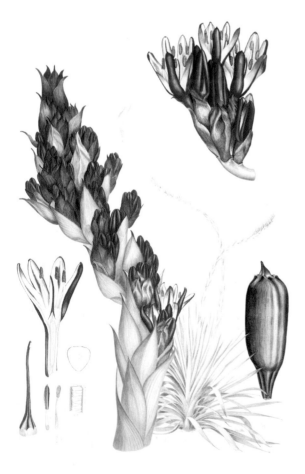

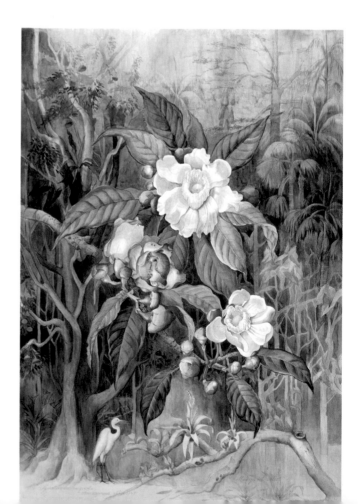

An old style for the new millennium

These artists have proved that it is possible to work quickly with watercolour, capturing a plant with all its character and all the detail necessary for identification purposes and, as a bonus, retaining the freshness of the living plant. They developed their skill out of necessity (earning a living and keeping pace with the sheer quantity of work). I too developed my skill out of necessity (earning a living while looking after a family, house and garden) and because I found an enjoyable and exciting way of painting and an excellent way to capture a living plant on paper.

This seemingly effortless field sketch of *Gustavia augusta*, with the watercolours quickly washed in and blended softly with water on the paper, says it all.

Gustavia augusta field sketches.
Margaret Mee. Watercolour. Copyright Royal Botanic Gardens, Kew.

Creating stunning botanical paintings with complete self-confidence in peaceful, comfortable surroundings sounds the perfect way to spend your days. We botanical artists should be the luckiest people in the world! Unfortunately, although others often imagine that we have the most idyllic, stress-free occupation, it is not always so. However, feeling comfortable in your surroundings and confident with your materials and your ability to use them successfully helps a great deal.

Peaceful painting

Mentally you have to switch off from day-to-day worries to become completely absorbed in your work. If you have only a short time to switch into painting mode before the next interruption, you will not be in the best frame of mind. If possible, cut yourself off from everyday distractions, and if it isn't possible to get away from them, try to shut them out of your mind – they can wait! A purpose-built studio with no type of communication a little way down the garden would be ideal. I am sure Walter Hood Fitch had no distractions whatsoever or he could never have created 9,960 botanical illustrations – and those are just the ones that were published! You have to be very self-disciplined and single-minded because you need uninterrupted time to concentrate on botanical painting – especially if you have cut flowers in front of you, which will soon wilt. If the phone rings in mid-petal or -leaf or mid-paper-stretching, you have to ignore it; an answer-phone should help but do not feel compelled (as I often do) to check for messages within a few minutes of the ring – it will be yet another intrusion to break your concentration.

Comfortable painting

If you are not feeling comfortable and at ease, you will struggle to become fully absorbed in your work. If you paint a lot, it seems inevitable that you will at some time suffer from head, neck or back ache, possibly wrist strain and, in later years, eye strain. Your body can become extremely tense while painting; try to relax and do not tense your neck and shoulders too much by leaning too far over your work to peer too closely. Concentrating for long periods is very tiring so take occasional breaks to relax your body and brain. Try to keep your painting arm, wrist, hand and fingers relaxed and fluid. Find what works best for you and take note of the following advice.

Your desk or table must be a comfortable height to sit at with your board tilted against the edge of the desk at a suitable angle for painting (if your paper is too low on the board, it will make painting awkward). You can work with your board right on the desk, either on a desk easel or leaning against a thick book, but your desk will need to be deep enough to place plant material ahead of you, behind your board. Some people manage to study specimens that are placed to one side of their board, but I find it much easier to carry an image vertically, looking up and down from painting to plant as I work. Paints and water-pots should be placed close to your painting hand. If your board is resting in your lap, it will probably be too awkward to reach paints on the desk; in my studio I have a small, movable, wooden cabinet that has several drawers for my art materials and is ideal for this. Do not work on a flat surface, as it distorts your image. However, if the surface you are working on is too steep, watery paints may run.

Your chair should be set to the right height to avoid body strain, with no arms to get in the way of your elbows. A hard seat soon becomes uncomfortable when sitting for long periods.

Background: a neutral-coloured wall makes a good background for your plant material. A self-supporting backdrop, shaped like a winged mirror and made out of mount board or wood, is useful for screening out distractions if there is no wall behind your desk.

Sound: I find radio programmes – speech rather than music in my case – relax my mind and distract it from my anxieties without diverting it from my work. Silence doesn't work for me.

Light: A good light source is vital to give your plant material three-dimensional form and reflect its true colours. Daylight is preferable, from a north-facing window and from your left if you are right-handed, from your right if you are left-handed, so that your hand doesn't cast a shadow. However, I spent 16 years painting by a lead-paned window in our bedroom, in a 16th-century cottage, to get the best light. It was south-facing and the shadow 'grid' thrown across my plants and paintings on a bright day could be very annoying. Much as I liked the sharp contrasts created by sunlight, I usually needed a sheer white curtain to filter the bright light. I managed somehow! 'Daylight' bulbs are the next best alternative but they cast a much harsher light on your plants than soft daylight.

Confidence in your materials

It is essential that you become entirely familiar with your materials and have confidence in them. I do not want to dwell too long on technical information about materials and equipment as my first book *Exploring Flowers in Watercolour* went into this quite fully. I use exactly the same paints, brushes and paper for my botanical illustrations as for my flower paintings. Here is a brief review.

Brushes

Use good-quality round brushes with sharp points. Kolinsky Sable is the best because it holds lots of water and it has an innate ability to spring back into shape after every brushstroke. These brushes can be expensive but a good-quality brush used for watercolour will last for years provided you rinse it thoroughly and wipe it with a tissue after use to restore the point – and never leave it standing in water. Some of the sable/synthetic brushes are excellent and especially useful in the larger sizes, which are expensive in pure sable. There are also some very good synthetic brushes, but choose those that have the two characteristics of sable: capacity and spring. Keep old brushes to use with masking fluid.

I find sizes 8, 6, 4 and 2 most useful for botanical painting; with experience you can produce great detail with their fine points and yet these sizes also hold plenty of water, which is vital with this 'wet' method of painting. Size 2 will cope with the very finest details and size 8 or larger is very useful when laying down large shapes. As a general rule when brushes are mentioned in the book:

very large = size 10–12, *large* = size 8, *medium* = size 6, *small* = size 4, *fine* = size 2.

The painting of the pansy on page 90 includes details of each brush used as a guide to help you decide which size is appropriate for different uses.

WINSOR & NEWTON COLOURS

*Winsor Lemon (WL)

*Winsor Violet (WV)

*Transparent Yellow (TY)

*French Ultramarine (FU)

New Gamboge (NG)

Ultramarine (green shade) (UG)

*Winsor Yellow Deep (WYD)

Indanthrene Blue (IB)

*Winsor Orange (WO)

Winsor Blue (green shade) (WB)

*Bright Red (BR)

Winsor Green (blue shade) (WG)

*Scarlet Lake (SL)

*Permanent Sap Green (SG)

Winsor Red (WR)

Burnt Sienna (BS)

*Permanent Carmine (PC)

Light Red (LR)

*Permanent Rose (PR)

Davy's Gray (DG)

Quinacridone Magenta (QM)

*Payne's Gray (PG)

DALER-ROWNEY COLOURS

*Lemon Yellow (LY)

*Quinacridone Magenta (QM)

Cadmium Yellow Pale (CYP)

*Permanent Mauve (PM)

*Gamboge Hue (GH)

*French Ultramarine (FU)

Raw Sienna (RS)

Indanthrene Blue (IB)

Cadmium Orange Hue (COH)

Phthalo Blue (PB)

*Warm Orange (WmO)

Hookers Green Light (HGL)

*Permanent Red (PR)

*Sap Green (SG)

Vermillion Hue (VH)

Burnt Sienna (BS)

*Quinacridone Red (QR)

Burnt Umber (BU)

Alizarin Crimson (AC)

*Indigo (I)

*Permanent Rose (PR)

*Payne's Gray (PG)

Paints

'Artists' quality watercolours are essential – they are more intense and translucent than 'Students' quality. Use a full spectrum of the brightest, most translucent colours you can find; you can easily dull down a bright colour but you can never make a dull one brighter. Manufacturers have prepared a fantastic range of light-fast colours so why struggle to mix everything yourself from a very limited palette? A box of half-pans is more convenient to use than tubes, but half-pans can be refilled from tubes.

Colours

The suggested colours shown opposite are Winsor & Newton and Daler-Rowney as these are the most readily available brands in the UK. The 12 colours marked with an asterisk (*) provide a good spectrum of colours adequate for botanical painting. The additional colours give even more scope and enable you to paint any subject whatsoever, including landscapes and seascapes. Throughout the book I have listed the colours used, where this is helpful, using the abbreviations shown in brackets opposite. Unless a brand name is specified in the text, they are Winsor & Newton colours.

Tips:
- My absolute favourites are Winsor & Newton's Scarlet Lake, Permanent Carmine, Permanent Rose, Winsor Violet, Payne's Gray, French Ultramarine and Permanent Sap Green; the last two are equally good by Daler-Rowney.
- You will not need a white watercolour as the paper is your white, though a tube of Permanent White gouache (which is opaque) is useful for final details such as veins and stamens.

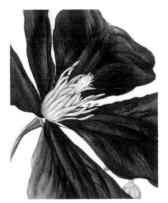
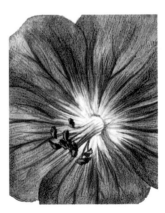

Note:

In my last book I used Winsor Yellow. The consistency of this pigment seemed to change around 1999: dry areas of Winsor Yellow seemed to blot up wet colour laid across or beside it, giving woolly edges to shapes (the cadmium colours also tend to do this), so I now use other yellows. In the colour notes for paintings that were originally created using Winsor Yellow, it has been replaced by alternative yellows.

Paper and other painting surfaces

Watercolour paper that suits me may be totally unsuitable for other artists who use different techniques. I need a paper with the following properties:

- A clean, bright appearance (not too dull or creamy) so it doesn't deaden bright colours.
- A surface that allows watery washes to be floated across its surface, giving time to blend and soften colours (not one that absorbs paint too quickly like blotting paper).
- Colours must fix well when dry so they are not 'washed off' by over-painting.
- It must take fine detail.

Since my first book was published, I have tried in vain to find the perfect paper but I still like Winsor & Newton's Cotman paper best as it has the properties listed above. There is one disadvantage to Cotman: it only comes with a 'Not' surface (slight surface texture) and there are times when I really need a 'hot-pressed' (smooth-surfaced) paper with the same characteristics of Cotman. Despite this, it is still possible because of its 'silky' finish to achieve great detail on this paper. Canson Montval paper also seems to work well with the wet technique and has a slightly smoother surface than Cotman; it appears to be more readily available in some other countries.

I always use medium weight 140lb (300gsm) paper and stretch it first by wetting the surface of the sheet and taping it to a board with gummed brown paper tape (gumstrip), so the painting will dry absolutely flat (see *Exploring Flowers in Watercolour* for a full explanation of the method). Some artists, particularly those who use hot-pressed (HP) paper, prefer to wet the back of the sheet in case the front is roughened; I find this rather unmanageable, unless you have another pair of hands to hold it down while you tape, as the paper curls the wrong way. Others stretch it after the painting is finished by wetting the back of the painting and taping it down until it is dry – I am too scared of getting water on the finished artwork to try this method!

Periwinkle on vellum (right)

Vellum is a painting surface favoured by many botanical artists and much used in ancient times. It is expensive, but the best artists can attain rich, luminescent colours and incredible detail on good-quality vellum. The skin is soaked, limed, de-haired, stretched and dried to produce vellum. The flesh side of calfskin makes the finest painting surface, but today, it is also made from the skins of other animals, such as sheep. It must be permanently stretched or gummed down to keep it flat and the surface needs de-greasing with pumice or 'pounce' powder prior to painting.

As it will spoil the surface if you draw and erase directly on vellum, you must make your drawing first on paper and transfer it onto the vellum or, of course, you could paint without drawing first. It is quite a forgiving surface, allowing paint to be lifted or gently scraped off and replaced to correct errors. Very watery blending of colour washes on the surface (wet in wet, which is frequently used in this book) does not work well on vellum but a combination of slightly drier wet-in-wet painting overlaid with dry or tiny brushstrokes, to build strong hues and tones, works well.

Some botanical artists use other surfaces, such as mounting board, for watercolour paintings. I would recommend that you get samples and test the suitability of your paints and your technique on that surface before embarking on a finished painting.

Other equipment

Two clear glass water pots. Keep clean water in one to use directly on the paper and to drop into colour washes; use the other one for rinsing brushes. As they get dirty very quickly, refill both pots frequently with fresh water.

A drawing board. Use one that is large enough to give you space to support your painting arm and hand. Two or three different sized boards are useful.

A roll of kitchen towel or strong tissues. I always keep a piece in my non-painting hand ready to dab my brush on it or blot up a mistake.

'Art masking fluid' or 'drawing gum' Useful for masking small shapes prior to painting.

A ruling pen To apply masking fluid.

Easy colour mixing

As far as possible, arrange colours in your paintbox from lightest to darkest and running through the colour spectrum, starting with yellows, through oranges, reds, pinks, purples, blues, greens and finishing with browns and greys. You need to find colours instantly, as time is of the essence with this wet method of painting. A small, painted chart of colours as laid out in your paint-box is useful to keep for reference. Water is perhaps the most important ingredient when mixing colours. Always mix little pools of watery colour (washes) in your palette; don't use colour neat from the pans or tubes. I have room for several different washes in the wells of the two hinged lids of my enamelled, metal paintbox and I mix smaller dabs of stronger colours on the flat, raised areas of the lids. Many paintings in this book are accompanied by colour strips showing each wash (a mixture of water and colours from the paintbox) that was used. Other complete paintings have a list of the main colours used but do not show the washes. For colour abbreviations, please refer to page 22.

Tones

The proportion of water to pigment varies the tone (light to dark) of your wash. For the pale-coloured Azalea flowers (below) the merest tint of pink and violet was mixed into the water, so that the paper showed through the thin, watery wash to produce a pale, delicate mauve. The darker, more intense, magenta flowers were painted with a more concentrated wash using more pigment. When mixing stronger colours you must still mix a little pool of colour, not a sticky blob; otherwise it will not flow off your brush onto the paper.

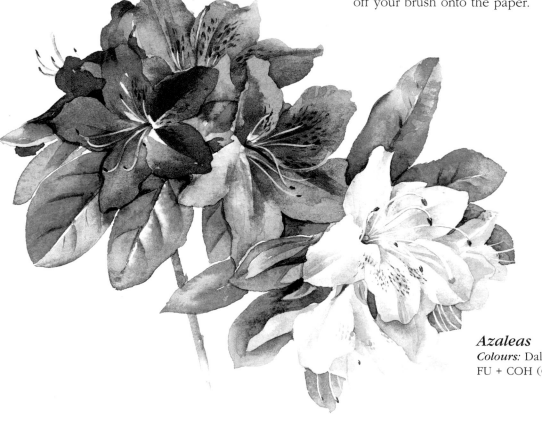

Azaleas
Colours: Daler-Rowney PR, QM, PM, FU + COH (Grey), SG.

Hues

To adjust the hues (variations of a colour) to match nature, simply mix a wash of the predominant colour and tint it with a little of one or two others, testing it on watercolour paper until it is a good match. A basic understanding of colour theory is helpful: red, blue and yellow are the three *primary* colours. If you mix two of these together, you get the *secondary* colours: red + blue = purple, red + yellow = orange, yellow + blue = green. With experience you will soon learn that a bright Sap Green, for example, will become more limey if you add some yellow (below), more olivey if you add a touch of red and so on, so that you can use Sap Green as your main colour for most foliage and change it to almost any hue of green by adding other colours. There are many different ways to mix the same hue and, with experience, you will find your own favourite combinations and use them again and again. Some hues are just impossible to match (really bright reds are especially problematical) and you just have to get as close as you can.

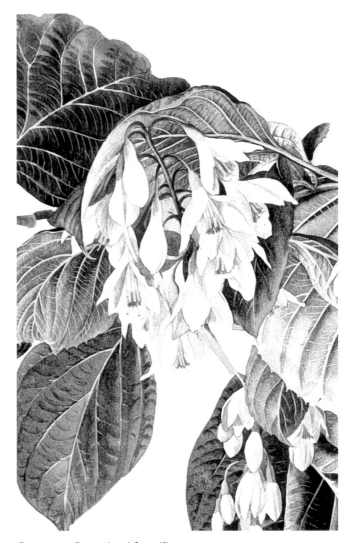

Styrax obassia (detail)
There are many different hues in these green leaves and strong tonal contrasts.

| SG, | SG + NG, | SG + SL, | SG + FU, | SG + PG |

Various hues of green

Forming shapes with confidence

I paint with little or no preliminary pencil drawing. Although I would encourage you to paint directly, without drawing first, the ability to draw an accurate image on paper quickly and confidently is a valuable skill. If you have the facility to see shapes, proportions and perspective and transfer them onto paper accurately, this is obviously an advantage when painting directly; practising drawing and quick sketches will help you to develop that skill. I am now happier with a brush in my hand than a pencil; with experience you may also gain this confidence so that you can cut pencil drawing to the absolute minimum or even paint without any preliminary drawing. The brush should become part of you, a natural extension of your fingers. Hold it near the top (handle end) of the metal ferrule – if you hold it too close to the brush head, you will have no flexibility.

Improving your drawing skills

There are many excellent books and courses on drawing and this book will concentrate on using brush rather than pencil. If you do not appear to have natural drawing ability, you can learn – the secret is to judge shapes, angles, levels and positions of crucial points and their relationships to one another, to constantly look at the whole rather than concentrating on one small area at a time. While painting a plant I am doing this continually, carefully judging the position of each reference point – the tips of petals, centre of a flower, where a leaf joins a stem and their relationships to one another. Which points are on the same vertical or horizontal line? What is the angle of a stem? Break everything down into shapes and angles in your mind's eye.

Preparatory drawing

If, despite perseverance and practice, you never feel confident without the safety net of that preliminary drawing, here are a few tips:

- Be as kind to the paper as possible – do not use a pencil that is either too hard or too smudgy. H or HB should be fine.
- Try to avoid rubbing out (erasing) pencil on watercolour paper wherever possible as it will spoil the surface. Cotman paper will stand a fair amount of gentle rubbing with a smooth white plastic eraser such as Staedtler Mars Plastic.
- Putty rubbers will lift pencil by pressing rather than rubbing, but some can leave a residue.
- Watercolour washes will often trap pencil lines beneath so they cannot be erased later; draw very lightly, and gently lift any dark lines by 'blotting' with an eraser before painting to leave only the faintest lines.

- If you cannot draft your image accurately without a lot of rubbing out, it may be best to draw your outline on cartridge paper, trace it onto tracing paper and then transfer it to the watercolour paper. A quick method is to draw over the back of the traced image and rub it off on to watercolour paper with the side of your thumbnail (the edge of a coin also works well but may flatten the paper surface). You will then need to place a sheet of paper under your hand so that you don't smudge the transferred pencil image. This process will, of course, greatly increase your preparation time.
- Many people have a tendency to draw and paint objects smaller than life size; in this case it is important to mark out the correct scale with pencil to stop your image from shrinking. If you wish to work larger than life size, pencil guidelines will also help you keep to a larger scale.

Painting without drawing

Although it may seem rather risky at first, and you may find it difficult to form accurate shapes without pencil guidelines, there are many advantages in working this way if you have the courage to try it:

- You save a lot of time.
- Paint that is washed in to fill outlined shapes can look too perfect and rather lifeless.
- Plants, especially cut flowers, are continually moving and opening; by the time you begin to paint, the pencil lines are often in the wrong place and have to be erased and redrawn.
- The paper surface may be damaged by drawing and rubbing out before painting.

Use the natural shape and flexibility of the brush when forming shapes – for example, when painting a pointed Iris leaf or a blade of grass, lay the pointed tip of a large brush on the paper and gradually, using more pressure as you sweep it across the paper, spread the hairs and widen the stroke; then gradually lift the pressure and end with a point again. Practise brushstrokes that start at the bottom (dragging the brush upwards) and others starting at the top (dragging it downwards). When forming shapes, lay the paint down by spreading the brush (don't just dabble with the tip) and you will find that paint is drawn off the tip of the brush to form smooth, sleek edges to your petals, leaves and stems. If watercolour is used quite wet there is time to mould, push and pull the paint into shape.

Tips:

- Keep your arm, wrist and fingers flexible so that you can pull brush and paint in any direction. If you feel that you have more control pulling the brush in one direction, you can always turn your paper a little to suit; I feel most comfortable pulling the brush diagonally in a north-easterly direction.
- To further improve brush control, practise painting fine, steady lines (like the veins on a leaf) with the tip of your brush. Hold the brush a little nearer to its head to give you more control and use your little finger, bent, as a brace to keep a steady flow of pressure as you slide your hand across the paper.

Streamlined, confident brushstrokes all made with a size 10 brush

If you observe any part of a plant – a stem, a leaf, a petal or a berry, for example – you will see that it is not just one flat colour, or even different tones of one colour; it will have many variations in hue and tone that may be very marked, such as the contrast of the white highlight on a red berry, or very subtle, such as the soft colouring and shading on a curving rose petal. It is these variations that make it look real and three-dimensional and if you do not imitate these subtle differences in your painting, the image will look flat and dull. The basic technique I use to achieve this is commonly known as wet-in-wet painting. In my early attempts at flower painting, this seemed to me to be the natural way to use watercolour paints to copy the subtle gradations of colour and tone that I could see on the leaves and flowers in front of me; several years later I discovered that it actually had a name!

There are variations in handling this technique and of course there are other techniques that are useful when depicting different surfaces and textures; all will be fully explored later, but for now it is enough to concentrate on the essence of the wet-in-wet method.

The wet-in-wet technique

The varied tones and hues in these examples (p30–32) were blended on the paper surface, wet in wet, in one layer and left alone to dry; nothing more was needed to make them look real.

Rose hips – step by step

Colours: SL, PC, PG, SG

1 Mix a fairly large pool of Scarlet Lake, adding a touch of Permanent Carmine to match the main colour of the berry. Mix a darker tone of this by adding more Permanent Carmine and less water. Take a few drops of this dark red wash with your brush and add a little more Permanent Carmine and some Payne's Gray to make a really dark red. You now have three different red washes ready to use at speed.

2 Paint the berry shape with the lightest red wash, leaving a large gap of white paper inside the shape; quickly use a clean wet brush to drag the colour towards the centre of the shape, so that the red softens away to a watery, pale red, leaving a little gap of white paper for the bright highlight.

3 Quickly blend in strokes of the medium red where needed and finally add a touch of the darkest red.

4 When this is dry, add a stalk and a dark raggedy top (using Payne's Gray) and it is virtually complete, in one layer of paint. Note that even the narrow stalks have varied hues and tones to give them form.

The all-important first layer

These examples show how much shape, colour and form can be achieved in one layer of paint, by working quickly using the wet-in-wet technique.

Rhododendron leaf
Colours: FU, WL, SG, PG

A clear wash with a hint of blue was laid down first, then mid and dark greens were added, wet in wet.

Turkey oak leaf
Colours: WL, NG, BS, SG

The main yellowy wash was painted first and the darker gold and green washes were touched into the wet paint.

Tips:

- Using the central vein as a natural division enables you to concentrate on just half the leaf at one time.
- As a general rule it is best to put down the lighter wash first and add the darker tones to this. But sometimes, as with the little stalks and twigs, it is more controllable if you put a little brushstroke of stronger colour down first and run a clean, wet brush or a lighter colour alongside to pull out the strong colour. This method of softening with a wet brush to fade colour away to nothing is used frequently in all my paintings.

With experience you should start to feel at ease with your technique, which will become second nature. You may already have been using the wet-in-wet technique without appreciating its full potential. Artists who have been using other techniques may have difficulty adjusting to a different style but they can still incorporate my method with their own to help them speed up. It is a riskier way of painting than the more structured and labour-intensive methods used by many botanical artists and at the end of the day some may find that it just does not suit them; it is not the only way to paint plants.

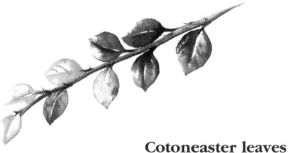

Cotoneaster leaves
Colours: FU, WL, SG, SL, PG

The main wash for the shiny leaves (clear water with a hint of blue) was laid down first and yellowy greens were added to the wet paint with a small brush. For the other leaves a yellowy wash was painted first and reds and greens blended in, wet in wet.

Important tips for successful wet-in-wet painting

- You have to work fast to blend the different hues while the shape is still wet. If the shape is beginning to dry, it is best to stop working on it and let it dry completely; then more contrast can be added on top of the first layer.
- Two or three different colour washes plus clear water are normally enough to achieve that 3-D form in this single layer. When stronger contrasts and details are needed they must be added later, after this first layer is completely dry.
- Putting the paint on quite wet, but not too wet, is the secret. If it is too wet, it will pool uncontrollably on the paper and you will lose those subtle differences of tone and hue. If it is too dry, you will not be able to blend the colours wet in wet on the paper before it dries out. Keep a tissue in your non-painting hand and dab the brush on it to remove a little liquid if it seems too wet.
- You can also 'mop' watery paint up from the paper with a damp brush and dab it off onto the tissue.
- Avoid 'blotting' the paper with a tissue to soak up wet paint; it will ruin that smooth, soft blending of colour that you are trying to achieve.
- Paint several petal or leaf shapes, to practise, until you are really pleased with one.
- If the white highlight is too sharp, the edges of the dry colour can be softened with a small, clean, damp brush, then blotted with a tissue.

Rose petals

Colours: TY, FU + WO (to make grey)

A fairly strong yellow wash was put down with a medium brush and pulled out across the paper with another wet brush to form the paler tones of the petal; some grey was stroked in immediately with a smaller brush and blended and softened with a clean, damp brush. Once the petals were dry, grey shadows were painted alongside their edges and drawn out with water to fade away to nothing. Although they looked real, I couldn't resist putting a few little touches of darker grey and a drop of water to bring the petals to life, again using the wet-in-wet technique with small brushes.

Tip:

- To paint a dewdrop, simply drip water onto the actual petal or leaf and look at it carefully; then use water to blend and soften tiny touches of colour to copy what you see. Try to retain that tiny white highlight or dot it in afterwards with white gouache.

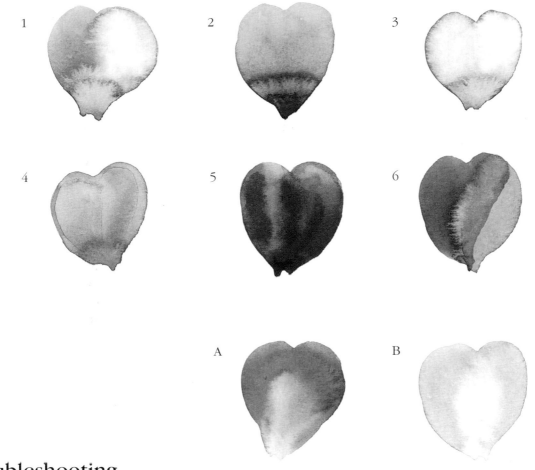

Troubleshooting

Wet-in-wet watercolour can produce strange effects that can be exciting and useful at times, but very annoying if they are unwanted. Some effects can be softened away with a damp brush (once the shape is completely dry) or disguised with dry brushstrokes so they are less noticeable, but it is much better to avoid them and try to achieve smooth gradations like petals A and B above.

1 Tidemarks or 'cauliflowers' may appear as a shape dries. These are caused by adding too much water (eg. when softening or blending on the paper) or by adding water a little too late when the shape has already started to dry; water floods back into the shape forcing the pigment into an uneven gradation.

2 Pooling happens when a little puddle of wet colour forms and dries after the rest of the shape, pushing the pigment up to the dry area. If you see a pool starting to form, mop it with a damp brush.

3 Dark rims are caused when too much water is flooded in, pushing pigment to the edge of the shape.

4 The shape has been outlined with the tip of the brush and filled in after the line has stained the paper. Avoid outlining – try to sweep colour around the edge and pull it over the whole shape.

5 The translucency and smooth gradations have been lost by overworking and muddying the paint. Do not continue to add and blend colours once the shape begins to dry.

6 A hard edge in the first layer has not been softened away with a wet brush before it stained the paper.

Building on top of the first layer

As a general rule, in watercolour painting, paler colours need to be laid down first and stronger colours added later. If you put down a strong colour first and it is in the wrong place, you will not be able to wash pale watercolours over it. The strong contrasts of darker pink shapes against pale petals are vital in forming this rose. Obviously all this variation and contrast could not be included in one layer of paint. The paler petals were laid down first and, once dry, darker shapes were laid on top, overlapping the pale wash where darker tones and contrasting shapes were needed. It can be rather tricky working on top of the first layer; the secret is to disturb the paint beneath as little as possible by laying washes down gently and moving the paint around as little as possible.

A rose – step by step

Colours: PR, PC, SL, WL, PG, SG, FU

1 A few minimal pencil reference points will help to indicate the shape and scale.
2 Prepare and test out your main washes for the flower. At least three tones of pink and a pinky grey will be needed.
3 It is sensible to start with the tighter centre of the flower, adding petals around this. Lay down a varied, light pink wash first, softening away any hard edges (where the rose shape will be extended) with a clean, wet brush.
4 When this first layer is dry, work onto it, gently overlaying the darker pink shapes, again blending, wet in wet, to vary the tones and hues within each shape.
5 Build up the outer petals around the centre, again using paler washes first; then overlay the darker undersides of the petals.
6 Mix your washes for the foliage. The paler undersides should be painted first and the darker faces of the leaves then laid down to overlap this first layer.

Tips:

• Use colours fairly strong to start with to avoid going over again and again to build up contrasts.
• Don't spend too long on the drawing: this rose was opening before my eyes; if I had drawn it fully first, it would have changed beyond recognition by the time I picked up my brush.

Other useful techniques

There are many examples of uses for these techniques throughout the book.

Lifting colour

To lift colour where a lighter
tone is needed, dry pigment can
be loosened with the tip of a clean
wet brush and blotted with tissue
to lift some paint.

Dry brushstrokes or feathering

Feathery brushstrokes are useful for adding texture, building up
very rich colours or smoothing over a messy area. Paint is
worked off the brush by stroking it on scrap paper to flatten and
splay the brush; feathery strokes can then be applied to the
painting. If the texture is too marked, it can be softened with a
damp brush.

Using masking fluid

This rubbery liquid is useful for masking small areas of
white paper before painting. Stamens, highlights and
small white flowers can be lost if you try to paint
around the shapes. If you mask them first, you
can paint over the dry masking fluid and rub it
off after the paint is dry to reveal the saved white
shapes; these can then be shaped and refined if
they look too coarse. Ruling pens, dip pens, cocktail
sticks and old brushes can all be used to apply it.
To help protect brushes, coat the hairs with soap
before dipping into the fluid and, when you have
finished, wipe with a tissue to clean – do not dip the
brush in water or it will be ruined.

4 FLOWERS: COLOUR AND FORM

Colour and form are inextricably linked, as it is variations in the hues and tones of colours that give flowers, or indeed any objects, their three-dimensional form. Using examples of single flowers that encompass a wide variety of shape, form and colour, you will see that it is possible to mix almost any hue, from the palest yellow to the richest scarlet. Colour strips show how the main colour washes were mixed. The method used to develop each form of flower is given, highlighting the importance of that first wet-in-wet layer when creating realistic forms. Several finished paintings of flowering plants show even more diversity of colour and form.

White

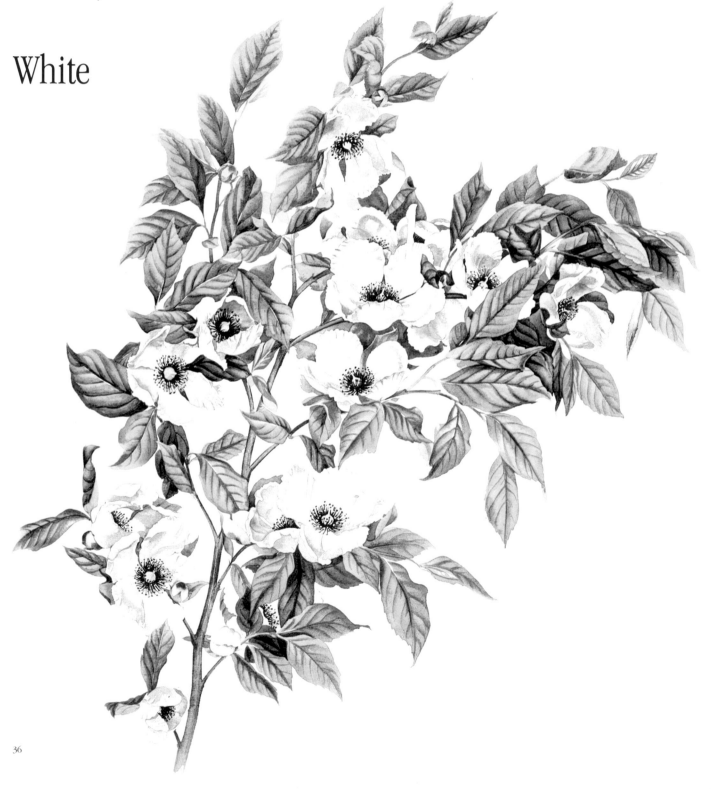

Freesia

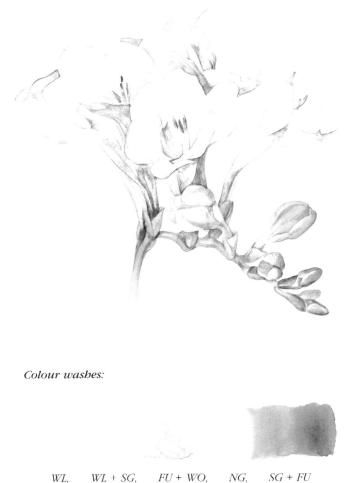

Colour washes:

WL, WL + SG, FU + WO, NG, SG + FU

Ensure that your flowers are set in a good light to give contrasts between light and shade; otherwise they will look pale grey all over. The white paper was in effect my first, white 'wash', so the first stage was to brush a little curving stroke of watery grey on one petal of the central flower and immediately soften this away with a wet brush. The other petals and the central hollow were formed in the same way to complete this flower.

Stuartia malacodendron (opposite)

Colours: WL, WB + WO or BR (greys), PC, PG, SG, FU

In midsummer, the branches of this spreading, deciduous tree are crowded with soft-petalled, creamy-white flowers that are accentuated by clusters of dark maroon stamens. The green leaves form a strong background contrast to highlight many of the white flowers.

The flowers behind were then added, grey shadows contrasting with the white of other petals, and finally the green buds and linking stem were painted.

Tips:

- When painting white flowers, what you leave out is more important than what you put in. Try to leave plenty of unadulterated white paper; too much grey will make the flowers look grubby and even a wash of clean water seems to take the sparkle away from a bright white.
- Blue and orange, being opposites in the colour spectrum (complementary colours) will mix to make grey and give you a wide variety of hues. Davy's Gray is useful if you need a very pale, neutral grey. I very rarely use Payne's Gray on flower petals as it is too intense, though it is essential when mixing blacks, dark greens, dark browns and rich maroons.
- It is always difficult to make white flowers stand out against a white background; wherever possible, compose your study with some foliage behind the flowers to throw them forward. The white freesia stood alone without any foliage nearby to form a contrast to the flowers – it would have been easier to portray it among other flowers and foliage in a mixed group.
- Putting in a dark background (either flat colour using gouache or a washy, watercolour background) is a more risky solution but can look stunning if you manage to pull it off.
- Never set white flower specimens against a white background as they will look grey – set against a neutral colour (slightly darker than the flowers), they will appear to be whiter.

Different hues of grey:

WB + BR WB + SL WB + LR IB + BS

FU + WYD FU + WO FU + BR FU + BS

Yellow

Argyranthemum 'Butterfly'

Colour washes:

WL, FU + WO, NG + WO, NG + WO + LR

a.

The first wash was laid down with a medium-size brush, blending in clear water for the palest areas (a). Once dry, the outer, ray petals and the pompom centre were formed on top with smaller brushes. The centre of the flower was made up of hundreds of tiny, five-petalled, trumpet-shaped flowers packed tightly together, but to the naked eye it looked like a soft textured mound so this is the effect I tried to create. Finally the dark leaves were painted, adding depth and contrast.

Tip:

- When adding darker tones and shadows to yellow or any light-coloured flowers, be careful not to overdo the shading as your flowers can end up looking dull and dirty. Here I left plenty of that first wash of bright, translucent yellow uncovered.

Hamamelis (Witch Hazel) *(opposite)*
[Clockwise from top left: *H. japonica* 'Sulphurea'; *H. × intermedia* 'Sunburst'; *H. mollis* 'Goldcrest' (reverse); *H. vernalis* 'Sandra'; *H. mollis* 'Goldcrest'.]

Colours: WL, TY, NG, WO, DG, SL, PC, LR, PG

Even in these tiny, ribbon-shaped petals the wet-in-wet blending of colours is still employed to good effect. Fine and small-size brushes were used to paint these plants and a good deal of patience and concentration was needed to paint such intricate flowers – my patience is limited and I don't attempt to paint such a demanding subject too often. I only wish I could have captured their wonderful fragrance, which fills the air on crisp winter days at the Sir Harold Hillier Gardens in Hampshire.

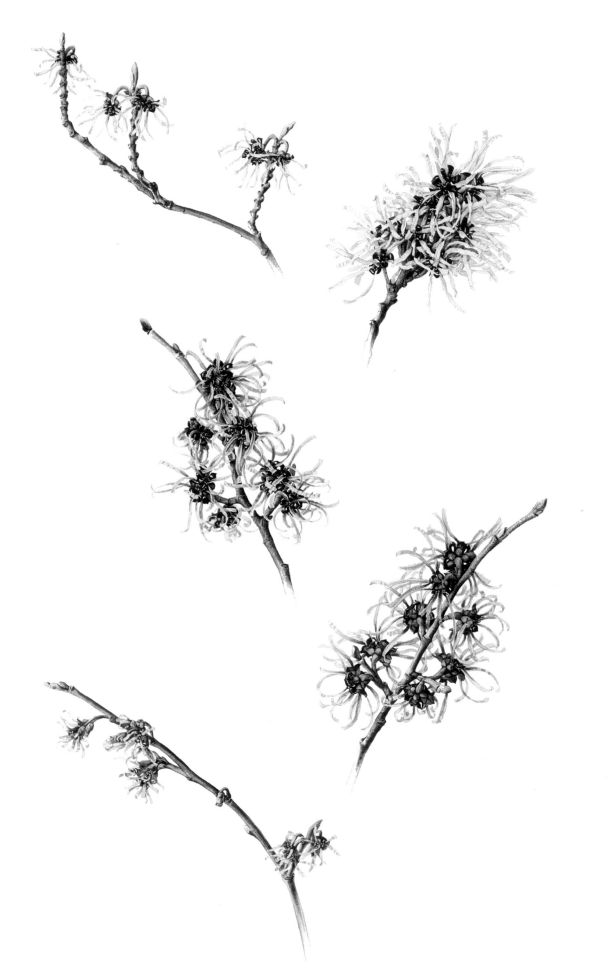

Hypericum patulum 'Hidcote'
(Rose of Sharon)

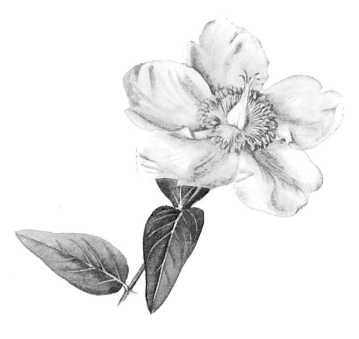

Colour washes:

NG, WL, NG + DG, NG + DG + WO, WO

A first wash of translucent yellow was laid down to form the shape of the whole flower and touches of stronger yellow were added, wet in wet, making sure that a small area of pale lemon was left in the centre for the carpel. The darker tones were then added to each petal and softened gently with a wet brush. It is always difficult to find the best shadowy greys to use on yellow petals; in this case I decided to use Davy's Gray for the shadows, but a blue/orange mix might have worked better. Details such as the stamens were added last.

Orange

Papaver nudicaule (Iceland Poppy)

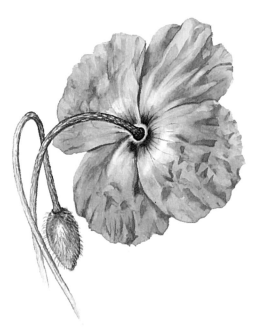

Colour washes:

WO, WO + BR, WO + BR + PC, SG, SG + TY

The petals were painted with a watery orange wash and a large brush, leaving a gap for the stem and further gaps of white for the silky sheen on the backs of the petals; when this was dry the edges of the white highlights were softened with a small, damp brush and blotted with tissue. Little geometric shapes of orangey red, sometimes softened with a damp brush, gave the crinkly character to the thin petals. The dark details, at the base of the petals, were added next. Lastly, the stem and bud were painted and finished off with fine hairs – a very important characteristic of these poppies.

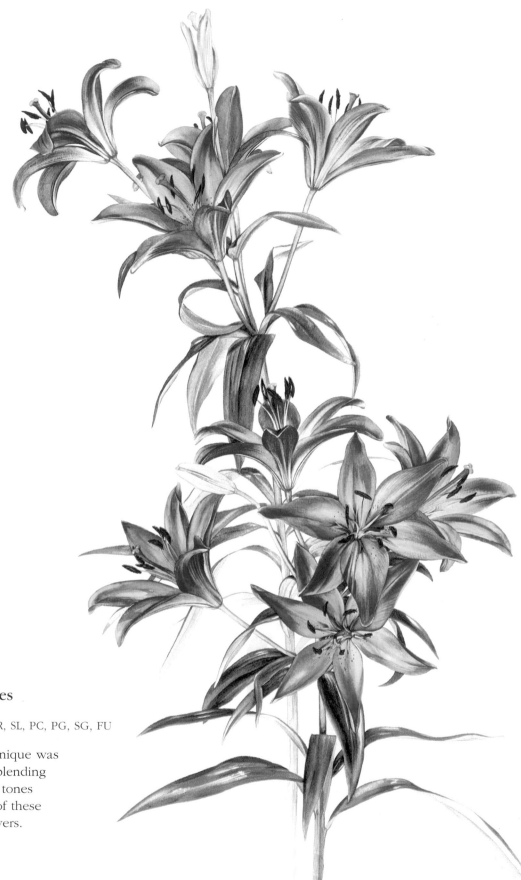

Burnt Orange Lilies

Colours: WL, WYD, BR, SL, PC, PG, SG, FU

The wet-in-wet technique was
perfect for the soft blending
of peachy hues and tones
on the large petals of these
trumpet-shaped flowers.

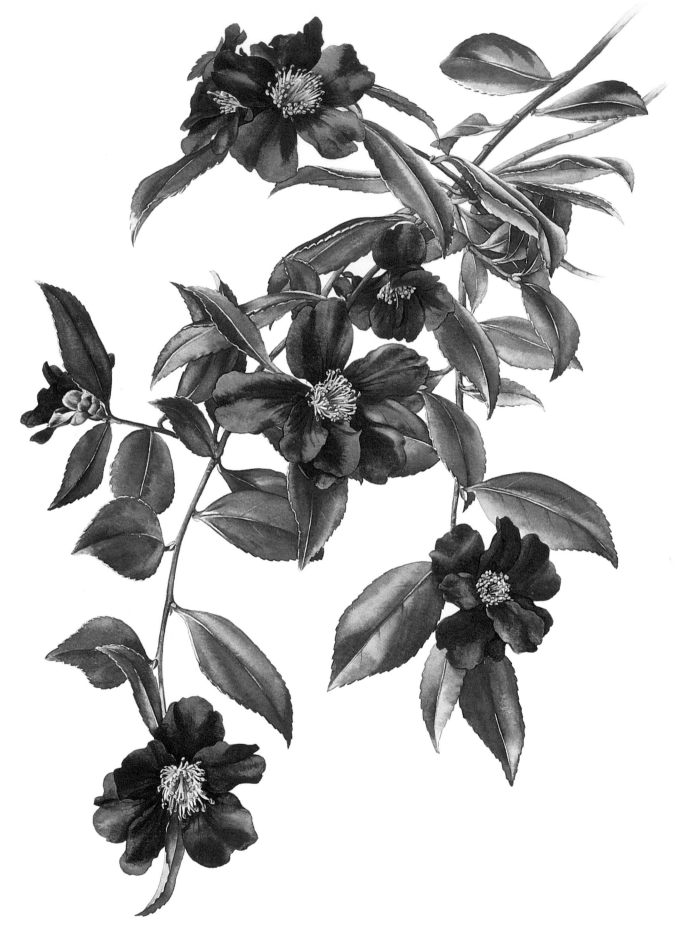

Red

Papaver rhoeas (Field Poppy)

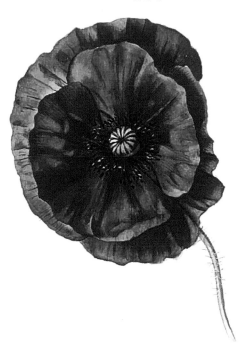

b.

Colour washes:

SL, SL + BR, SL + BR + WO, WR, PG, FU + SG

Camellia sasanqua 'Crimson King' (opposite)

Colours (Daler-Rowney):
LY, GH, PR, QR, QM, FU, SG, I, PG

The single flowers of this soft red camellia glow like rubies on bleak February days when there is little colour around. Daler-Rowney's Quinacridone Red was the principal colour used for this unusual hue. Painting a crown of bright yellow stamens against dark red petals with translucent watercolours needed some thought (see 'Details', page 82).

This is a flower that always looks best when painted really quickly with vibrant, loose, watery paint and then left alone. There were many different hues of red in this one flower. Using medium and large brushes, the whole shape was painted with a Scarlet Lake wash, adding clear water for the silky highlights, and touches of orangey red, wet in wet (b). A gap was left for the capsule and when the petals had dried this was filled with a watery blue-green (this could have been painted first, before the petals). Then stronger reds were overlaid and softened where necessary with a clean, wet brush. The contrast of these strong reds against the paler shapes of the first layer gives the individual petals form. Touches of greyish shadows were added and finally the tiny dark stamens and details on the capsule were put in with a fine brush; a few tiny highlights on the anthers were added with white gouache.

Red rose

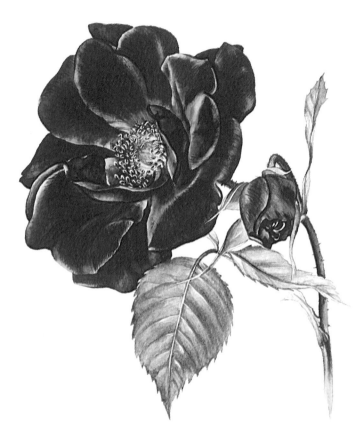

c.

Colour washes:

WL, FU + WV, SL + PR, WV + PR, PC

Red roses are notoriously difficult to paint. This one was semi-double for a start; unlike the single-flowered hypericum, for example, there are more petals to cope with. Intense colours are more difficult to handle in watercolour than pale, watery ones.

This flower also had a light, velvety sheen which, being in effect the palest colour, needed to be put down first (using a watery FU + WV wash) along with the pale yellow centre. Stronger reds were blended into these, wet in wet, on the paper (c). Working on a section of the rose (the whole shape being too much to cope with at once), deeper reds and maroons were added and softened away in places with a damp brush. When dry, the rich tones and velvety texture were built up with dry brushstrokes, which helped to form strong contrasts between the individual petals. The bud was added next, then the leaves and finally the stem. For advice on the yellow stamens (see 'Details', page 86).

Pink

Silene dioica
(Red Campion)

Colours: PR, PC, FU, SG, NG

British wild flowers usually have a softer,
more fragile character and form than garden
plants. To suggest this, I decided to finish
off this painting by damping the paper around
the completed flower stems and softly painting a few
more in the background to blend into the wet paper,
giving a faint impression of more wild flowers without
detracting from those in the foreground.

45

Rosa chinensis 'Mutabilis'

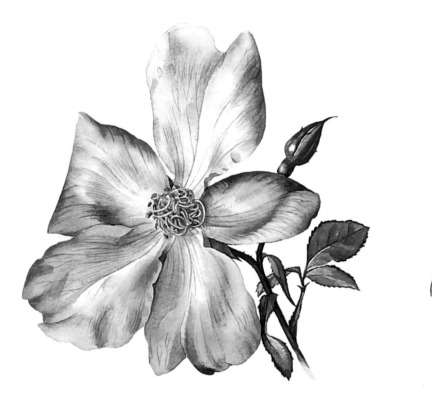

Colour washes:

WL, WL + PR, PR, FU +WO

Each petal was worked individually and a watery
lemon wash and a pink wash were blended with clear
water on the paper using large and medium brushes
(d). When these were dry, stronger pinks and
shadowy greys were added in the next stage. Finally
the little dark shapes among the cluster of stamens
were picked out and the fine, grey veins on the petals
were stroked in with the point of a fine brush.

Cistus × purpureus 'Betty Taudevin'

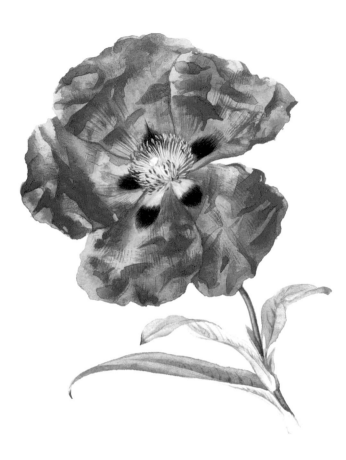

e.

Colour washes:

NG + WO, PR, PR + FU, PC, PC + WV

Permanent Rose was the perfect colour here and the
watery blending of different tones of pink simulates
the soft, silky sheen on the papery petals (e). The
darker, crinkly shadows were overlaid after the pink
wash was dry. Finally the dark blotches and stamens
were added.

Fuchsia

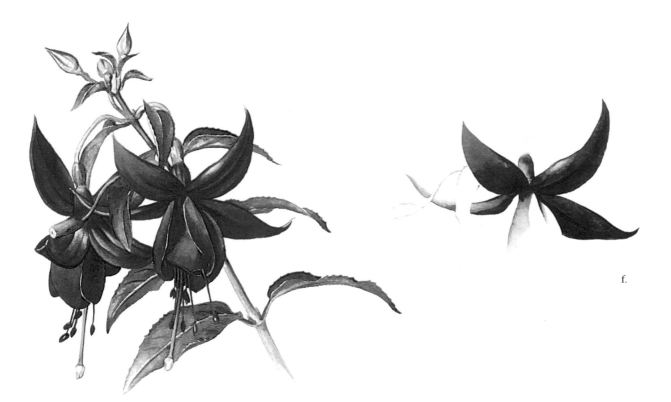

f.

Colour washes:

PR + SL, PC, PR, PR + WV

It was important to capture the pendulous habit and distinctive structure of these flowers. The outer 'petals' (which are in fact sepals) were painted first, leaving gaps where the leaf and stalk cross over the rear flower (f). To paint the petals, which form the bell-shaped flower below, a purple wash was blended into pale pink, wet in wet, on the paper. The contrasts were strengthened by adding darker carmine to the sepals and darker purple to the flower below. The overlapping leaf and stalk were added afterwards, along with the other leaves, buds and stem.

Purple and maroon

Rosa 'Souvenir d'Alphonse Lavallée'

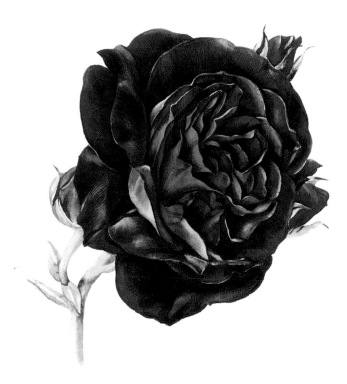

g.

Colour washes:

FU + WV, PR + WV, PR + more WV, WV + PC + PG, PR

This rose is multi-petalled, or 'fully double' to use the technical term. The painting was built up in much the same way as the red rose, though two pale, bluey-mauve washes were softly blended onto wet paper for that first layer (g). When this was dry, stronger pink and maroon petals were worked on top for the central, tight-petalled area and then the outer petals were added. Finally the deepest maroon was intensified to create more depth between the rose petals and dry brushwork was used to simulate the soft, velvet texture of the petals.

Tip:

- If you make a mistake and something looks wrong, quickly wash the paint away with a clean wet brush, before it dries and stains the paper, then blot it with a clean, dry tissue. Wait until this area has dried completely before painting over or next to it. Some colours stain more than others.

Clematis viticella 'Etoile Violette'

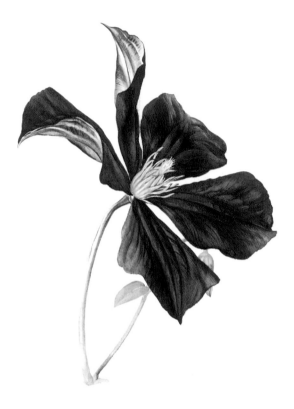

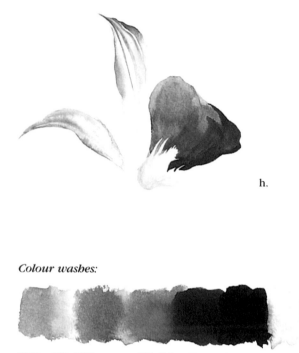

h.

Colour washes:

WV + FU, WV + more FU, PC + WV, PC + more WV, PC +
WV + PG, WL, WL + SG

The pale-coloured backs of the petals were painted
first and the pale lemon-lime centre for the stamens
(h). When dry, the dark faces of the two twisted petals
were laid down, overlapping the pale backs. Next the
two petals behind the stamens were added using the
sharp point of a small brush loaded with purply paint
to point in between the lemon stamens and drag the
paint outwards to blend into a purply-blue wash,
which formed the shape of the petal. Using the colour
quite wet gave just enough time to form this whole
shape at once and time to stroke in some darker tones.
After the first layer had been laid down for each petal,
stronger tones were gently stroked over and softened
where necessary with a damp brush. Some little pointy
stamens were lifted out with a fine wet brush and
blotted with tissue, to remove the strong pigment,
before they were touched up with gouache and the
fine details added.

Tips:

- When forming a petal you should take the wet
 colour out to fill the whole shape – otherwise
 when the paint dries, it will form an edge that will
 be difficult to obscure if it is in the wrong place. If
 you are not confident about filling the whole shape
 accurately in one go, then simply blend away the
 colour with a clean, wet brush to avoid a hard edge
 forming and paint in the rest of the petal after this
 area has dried.
- When building up rich velvety colours like these,
 try to use really strong colour in the first layer to
 avoid going over again and again.
- If you lay watery paint over strong colour, it will
 tend to lift and move the pigments below – keep
 subsequent layers fairly dry and concentrated and
 soften with a damp rather than a wet brush.
- Feathery dry brushstrokes are very useful to give
 real strength of colour and to cover patchy
 paintwork.

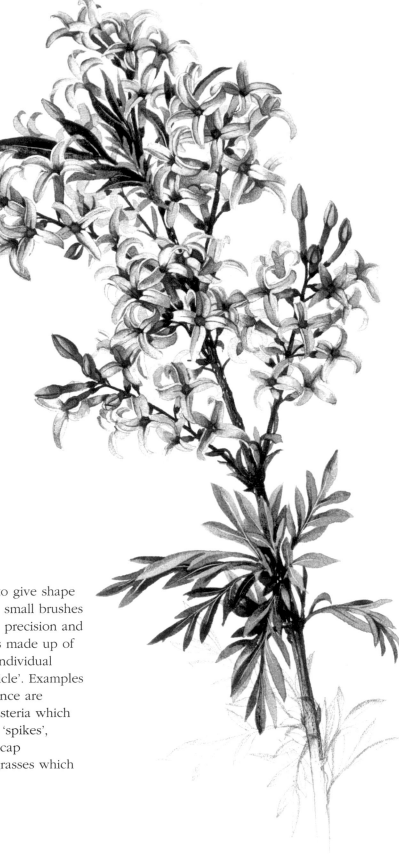

Syringa protolaciniata

Colours: WV, PR, PC, PG, SG, FU

The wet-in-wet technique is still useful to give shape and form to these tiny flowers but quite small brushes (sizes 2, 4, and 6) were used for greater precision and control. The head of this unusual lilac is made up of an inflorescence (a group or cluster of individual florets) which in this plant forms a 'panicle'. Examples of other shapes formed by an inflorescence are rhododendrons which have 'umbels', wisteria which form 'racemes', gladioli which flower in 'spikes', honeysuckles which have 'whorls', lace-cap hydrangeas which have 'corymbs' and grasses which have 'plumes'.

Blue

Echinops bannaticus (Globe Thistle)

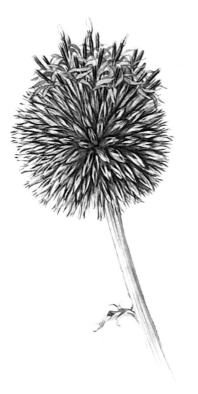

i.

Colour washes:

FU + PR, FU + WL, WV + PG, SG

This spiky, globose head of pale blue flowers was quite a challenge and needed some thought.

An area of paper was wetted and a pale blue wash was blended in. Next the 'hat' of pale blue flowers was added with a small brush and darker tones worked in with a fine brush to pick out individual petals and stamens. A greeny wash was carefully painted in around the little, pale bud shapes and blended with a small, damp brush (i). It took time to mark them all out but the trickiest part was now over. Fine purply-blue details were added bit by bit and the depth was built up in between the buds with very dark colours, which were softened outwards with a small damp brush. One head was more than enough for me!

Tips:

- When forming a soft shape with no hard edges, it is important to wet an area of paper larger than the shape so that the colour does not run to the edge of the damp area, thus forming a hard edge as it dries.
- Masking fluid could have been applied over the first wash with the tip of a pointed brush to save the pale tips of the little buds before overlaying darker colours. After rubbing it off the little shapes (which would probably be a bit coarse) could have been refined and the fine detail added at the end.

Vinca major (Periwinkle)

Colours: FU, WV, PR, NG, SG, PG

The periwinkle has been one of my favourite plants since I was a child. I love the unusual geometric shape of its flower with a little tube extending from the delicate calyx and opening into five flat petals or 'lobes'. The neat, pentagonal hole at the mouth of the tube contrasts with the pale centre of the flower. Neat, rolled-up buds and smooth, glossy leaves add to its character.

Geranium himalayense (Cranesbill)

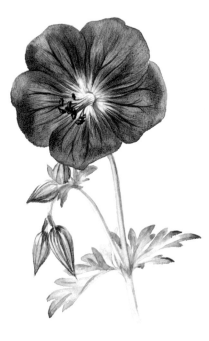

j.

Colour washes:

PR, PR + FU (pale), (medium), (dark), PG

After testing various colour mixes, Permanent Rose mixed with French Ultramarine (rather than Violet) seemed the best match for this vibrant colour. The central area was wetted and a purply-blue wash was painted in to form the outer edges of the petals and blended into the wet centre; some pink was stroked in while it was still wet (j). Stronger colours were overlaid and gently softened to form the contrasts needed to separate the petals and give them form. A few dry brushstrokes helped to soften and blend the petals and the fine veins and stamens were added.

Tip:

- It can be difficult to achieve a really smooth gradation in the first wet-in-wet wash, especially when using French Ultramarine, which tends to granulate. If the first wash looks a bit messy in places, do not panic as this can usually be concealed by the second stage of painting. I have yet to find a perfect blue watercolour but French Ultramarine is the purest and brightest and its slight granulation can often be useful.

Black

Gaulois 'Hamlet' (*Rothschildianum* 'Whitethroat' × *Goultenianum* 'Geysernight') **(Black orchid)** (opposite)

Colours: WL, SL, FU, PC, WV, PG

As you can see from its name, this hybrid *paphiopedilum* orchid went through a long development process on the path to try to create the ultimate 'black' orchid. I got the chance to paint it while it was on loan to Wyld Court Rainforest Gardens. I couldn't decide whether it looked dramatic or evil but apparently it was worth a great deal of money! I wish I had painted the leaves, as they might be important for identification, but I didn't have time before the plant went on show to the public. Winsor & Newton's Payne's Gray and Permanent Carmine were the essential ingredients to attain this rich, almost black, hue. Retaining the white shine of the paper was vital in creating the waxy quality and sculptural form of the 'slipper' shape.

5 FOLIAGE: COLOUR AND FORM

The leaves, stems and branches of a plant are very important for identification and to give it character and individuality. Although some leaves are very complicated, most have simpler shapes and flatter forms than flowers and should therefore be easier to paint. It is still vital to capture those subtle variations in hue and tone if you are going to create curves and bulges, twists and turns in the form of a leaf, and the wet-in-wet technique can do this beautifully. It is also important to portray the correct colour, texture and character – is it silky, shiny, leathery or velvety? My first book demonstrates more fully the painting of leaves with sheen or shine, variegated, serrated and Autumn leaves.

Quercus oglethorpensis

Colours: WL, NG, WO, SL, SG, FU, PG.

The watery blending of washes on the paper is ideal for leaves.

Shiny or glossy leaves

Camellia japonica 'Nobilissima'

Flower colours: WL, WOD, FU + WO/BR (greys)
Foliage colours: FU, SG, NG, PG, PC

This snow-white camellia is one of the first to flower
each year. Its leathery leaves are a glossy, bottle-green
with a pure white shine. Working on half a leaf at
a time by using the central vein as a gap
between the two halves, a watery blue wash
was blended away to nothing with a
clean, damp brush, leaving areas of
white paper. Rich blue-green washes
were quickly blended into the wet leaf
shapes. Minor veins were added later
(see Veins, page 70).

The very darkest tones were gently
overlaid and softened away where
necessary in the second layer. Where
there were bulges between the veins,
a stroke of dark green was gently laid
alongside the vein and softened away
along its other side with a wet brush.

Tips:

- Use Payne's Gray mixed with greens to get
 a rich, dark, bottle green.
- Try to leave patches of white paper for the
 shine. White gouache, added on top of
 watercolour, never works as well.

Magnolia grandiflora 'Goliath'

Flower colours: WL, FU + WYD/WO (greys), SL, PC
Foliage colours: WL, NG, WO, PC, SG, FU, PG

The huge, ivory flowers of this showy,
large-petalled magnolia have a sweet,
lemony scent. They contrast with
equally splendid leaves, which
remind me of patent leather
shoes – their undersides have a
dry, flocked texture. The rusty
undersides (being paler than the
surfaces) were usually painted before
the green topsides. It was important to
leave plenty of sparkly white on the
shiny surfaces of the leaves. The central stamens and
the fruit on the right were organic works of art which
deserved careful attention to detail.

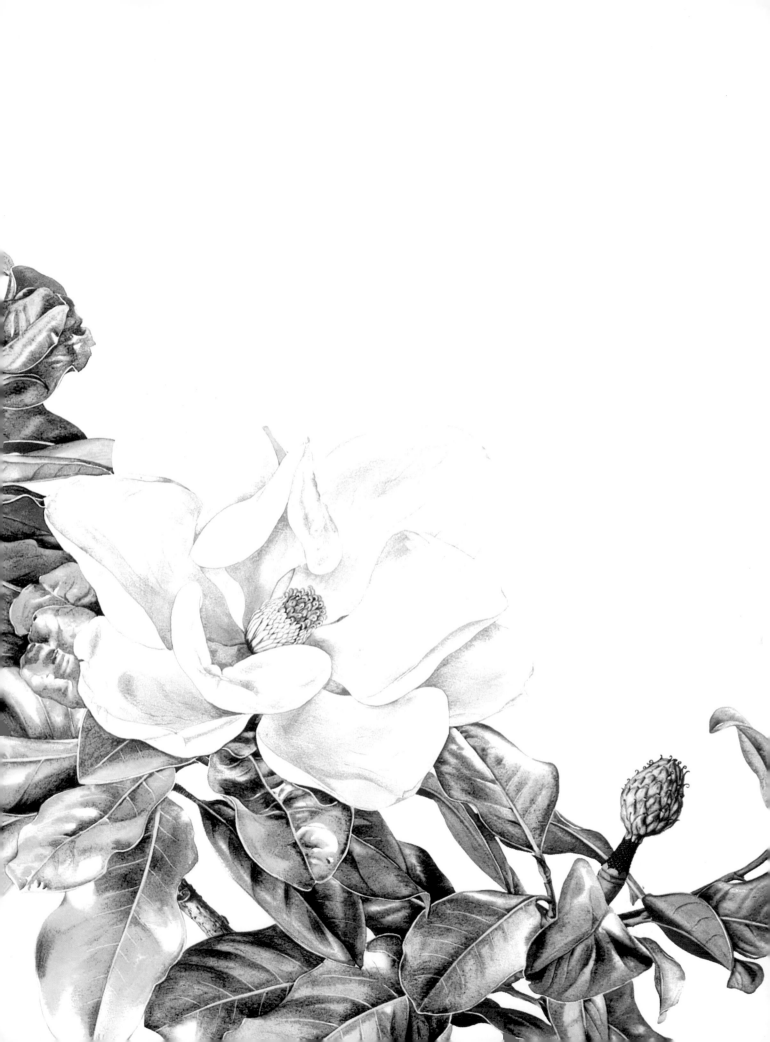

Leaves with sheen

Lonicera henryi

Flower colours: TY, SL, PC, FU
Foliage colours: FU, SG, TY, SL, PG

Many leaves, like those of this
honeysuckle, have a soft sheen that reflects the
light and helps to give them three-dimensional
form. Water with a hint of French Ultramarine
was used here for the lightest tones; soft green
and stronger green washes were blended in, wet
in wet, to create the sheen on the smooth
surface of the leaves. Each leaf was more or
less completed in one layer with little more to
do on top.

Dull, felty or flocked leaves

Styrax obassia

Flower colours: TY, WO, PC, FU + WO/BR (greys)
Foliage colours: WO, SG, Oxide of Chromium, FU, PG

This plant forms a beautiful drooping tree with long racemes of pendulous, snow-white flowers dangling below the large leaves; you need to walk beneath the branches to fully appreciate its beauty. The white flowers had to be painted first and pencil outlines were drawn to make it easier to paint the foliage around and behind them. Although there are some pale tones on the leaves, there are no white highlights or thin watery washes here to reflect the light and make them look shiny; the washes are more opaque, giving a soft, felty look. The ridged structure of the veins on the pale, silvery backs of the leaves is an important characteristic of the plant.

Tips:

- Oxide of Chromium is a rather chalky, opaque, green watercolour which can occasionally be useful for dull leaves.
- Dry brushstrokes are a useful finishing touch for a felty or flocked texture.
- White gouache, either dry brushstrokes or tiny individual hairs, will give the impression of fine silvery hairs on a leaf, sepal or stem.

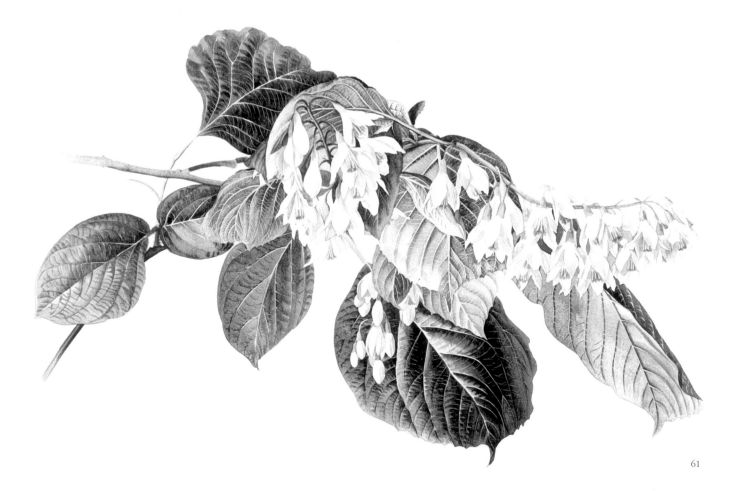

Bumpy leaves

Primrose leaf

k.

Colour washes:

WL + SG + WO, SG + WO, SG + FU + WO, SG + FU + PG

The veins on a primrose leaf are like gathering threads in smocking, causing the leaf surface to bulge up between them. To create this bumpy surface, a watery green first wash was laid down and stronger colour dabbed, here and there, onto the wet leaf shape to start to give the impression of bulges and hollows (k). When this was bone-dry, stronger green was overlaid with a small brush for the dark indentations and softly blended away with a damp brush to form the raised bulges. A pale wash was run along the light central vein to tint it and the fine pale veins were lifted and touched up with gouache (see Veins, page 70).

Tip:

● Bulges can also be 'lifted' out of dry pigment with a wet brush and tissue or by blotting up colour from a still-damp wash with a clean, moist brush.

Variegated leaves

Ilex × altaclerensis 'Lawsoniana'

Berry colours: SL, WR, PC, PG
Foliage colours: WL, WYD, SG, FU, PG

4 Then the darkest greens were painted on top after the first layer was dry and softened away in places with a damp brush.

6 The berries could be added last as they were behind the leaves.

3 Shadowy tones were overlaid on the gold areas of the leaves.

5 Finally some very fine lines were painted around the edges of the leathery leaves – an important little characteristic, not to be missed.

1 Working on the front leaf first, and painting half a leaf at a time, a watery wash with a hint of blue (for the shine) was blended into the watery yellows on the paper.

7 The stem was the final addition.

2 Immediately, soft greens were stroked onto the damp leaf to create blurred blotches and as the paint dried, some touches of stronger blue-green were merged in.

Primula veris (Cowslip) (opposite)

Colours: WL, TY, WYD, SL, SG, FU, PG

To faithfully copy every single crinkle and bulge would take forever, and is only bearable for those who have endless patience.

Autumn leaves

Oak

Colours: WL, WYD, SL, PC, SG, FU, PG

4 Painting little blemishes on leaves is very satisfying and these little peculiarities finish off a botanical study and bring it to life.

2 Then the darker tones and details were added.

3 This little sprig was completed by adding the acorns hanging behind the leaves.

5 The top sprig was painted next – galls first, then leaves.

6 Finally the cluster of acorns to the right was painted, followed by the rosette of leaves behind them.

1 The lighter-toned, autumnal leaves were formed first, blending gold, rust and green washes wet in wet on the paper.

Tip:

- Dead, decayed or skeleton leaves have lovely, earthy hues and sculptural shapes; they can look great when painted in detail with all their imperfections.

Lonicera prolifera (opposite)

Flower colours: WL, WYD, SL, FU + WYD (grey)
Foliage colours: WL, SG, WB, FU, PG, PC

Glaucous leaves have a beautiful blue-grey patina on the surface. This unusual honeysuckle has some perfoliate leaves (fused together around the stem) and a wonderful glaucous hue; Winsor Blue and French Ultramarine were the main ingredients here for colour washes which were tinted with Sap Green or yellow to vary the hues. A very pale, watery, blue-grey wash, which allowed the white paper to shine through, was used for the silvery hue of the undersides.

Glaucous leaves

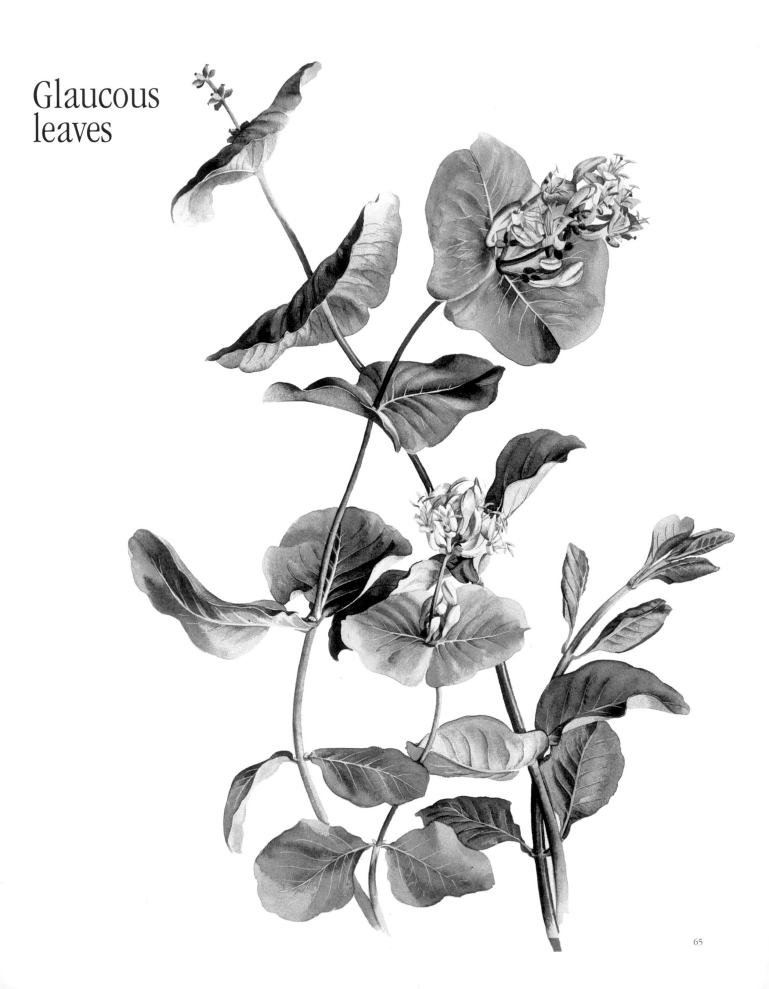

Complicated shapes

Acer leaf

Colours: SG, WL, FU, SL

This cut-leaf maple was deeply incised. Such a complex, spread-out shape can easily become distorted if you paint directly on the paper. A few pencil lines to mark the central axis were helpful without restricting the flow of the brush as I painted each 'arm' with small brushes (sizes 3 and 4).

Tips:

- When painting intricate leaves with small brushes, you can still use quite wet washes and the wet-in-wet technique.
- When painting a serrated, dentate or incised leaf (with points around the edges) or a fern, the sharp

tip of a brush, loaded with wet paint, can be laid repeatedly along the curving edge of the leaf. Immediately (before the row of points has dried) the wet colour is drawn into a wash to form part of the leaf. The serrations can then be refined and neatened with a fine brush later.

- With complicated leaf shapes, such as maple, ivy or oak, use the main veins as a division to enable you to work on a section of leaf at a time. Trying to paint the whole shape in one go is too much to tackle.

Leaf markings

Maranta leaf

1.

Half the leaf of this houseplant was painted with a wet, pale green wash and darker green blended into the wet shape to vary the tones. There was just enough time to stroke in touches of chocolate-brown with a smaller brush so that it blended softly in the damp first wash, leaving blurry shapes to build on later (1). This was repeated for the second half. When absolutely dry, darker tones of green were overlaid and softened away with a damp brush to merge into the first layer. Finally, the dark blotches were dry-brushed.

Colour washes:

SG + WL + FU, SG + FU + WO, PC + SG

Actinidia kolomikta

Colours: WL, SG, FU, PG, SL, PC

The wet-in-wet technique is very useful when trying to achieve a soft blending of one colour into another. The leaves were painted one at a time, blending colour washes and water on the paper and using the central vein to divide them into two sections. The bulges between the veins were formed as for the camellia leaves (see page 57).

Tips:

- When adding soft, blurred shapes wet in wet on the paper, use a small brush and fairly concentrated (but still wet) colour. If either the wash on the paper or the wash you are touching in is too watery, the colour will run too far and mix uncontrollably.

Pine needles

Pinus × schwerinii
(The Hunt Institute for Botanical Documentation, USA)

Cone colours: WL, WO, SL, BS, FU, PG
Needle colours: SG, WL, SL, WB, FU, PG and Permanent White gouache

Pine needles are not just lines of flat colour; they are
three-dimensional forms that need tonal contrasts to
make them stand out on the paper. The needles which
hung in front of the long, pendulous cones were
painted first, then the cones were painted 'behind'
these needles (pale washes first with darker contrasts
overlaid); these long, thin needles needed some
touching up later, after the cones were finished. Each
clump of needles was painted with long, thin strokes
of paler, blue-green washes, then gradually working
between these with darker strips of colour. In some
areas (unusually for watercolour) the darker needles in
the background were painted first, while the lighter
needles, which crossed in front of them, were lifted
out of the dry paint and refined by tinting with other
colours, often with the addition of white gouache to
make them opaque and silvery in colour and to help
block out the dark colour behind.

Tips:
• It would take forever to faithfully replicate every
individual pine needle but do observe the details
and overall character and habit of the plant
carefully. Don't be tempted to save time by
repeatedly painting simplified and stylized needles.

Veins

Leaves would be very simple to paint if they did not have veins. Study the veins on a leaf before you decide just how you are going to put them in. They may be almost unnoticeable, in which case the merest indication that they exist will be enough. If you give them too much emphasis, it will change the character of the leaf. They might be very fine or thick, deeply indented, lighter or darker than the leaf colour or brightly coloured; the veining structure on the back of the leaf may also be an important characteristic. I use various techniques for veins and choose those that are most practical in each instance – often I will use a combination of all the techniques explained here on one leaf.

Ranunculous ficaria (Lesser Celandine)

Colours: WL, TY, WYD, PC, SG, FU, PG

The veins on these fresh green, celandine leaves were painted using a combination of all the methods below, except masking fluid.

Dark or indented veins

a.

These fine details are added last using a fine brush to paint smooth, dark, hair-fine lines; if they look too obvious or coarse, quickly run a damp brush along one side of the line to blend it in slightly (a). For more deeply indented veins, such as *Rosa rugosa* leaves, use the same technique, pulling the strong, wet colour of the veins out with a small, damp brush to form little raised shapes and create the 'rugose' surface.

Leaving gaps for light veins

The leaf sections between the veins were painted, leaving a skeleton of gaps for the main veins. It is not practical to paint the shapes between hundreds of fine, light veins, as each leaf would take days to paint, but it works well if you leave the main veins (which form useful divisions when working wet in wet) and use other methods to complete the finer veins. White paper veins can be refined by washing in a tint with a fine brush (b) and neatened up or emphasized by painting colour either side of the vein with a fine brush and gently blending it outwards with a damp (not wet) brush (c).

Lifting out light veins

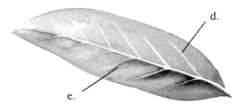

It is usually more practical to concentrate on getting the shape and form of the leaf right and ignore most of the veins until later. They can often be lifted out of the leaf; to do this, stroke the tip of a fine, wet brush over the dry colour to loosen a hairline strip of pigment (you may need to go over it carefully a few times) and immediately blot with clean tissue (d). If these light veins are a little vague, you can refine them by emphasizing the colour either side (e). Some pigments stain the paper and are difficult to lift out.

Using gouache for veins

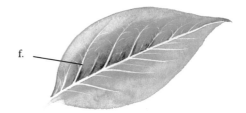

If the veins have been lifted but they need a little more lightening, a fine stroke of white gouache, tinted with colour if necessary, can be added as a finishing touch (f). Tinted or pure white gouache can also be painted directly on top of dry watercolour for white or pale-coloured veins, but the underlying colour may be absorbed by the wet gouache and a second coat may be needed.

Masking fluid for veins

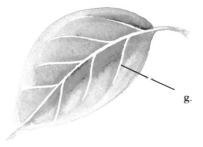

This can be used with a fine brush or pen to mask and preserve fine lines of white paper before washing the leaf shape over the top. When the paint is dry, the masking fluid can then be rubbed away revealing white lines, which can then be refined. However, I do not recommend this method, as leaves need to be fully and accurately drawn first to ensure that the veins are in the right position on the leaf; it is rather a clinical procedure, putting all the veins in before you even dip your brush in paint, and it tends to leave rather unnatural, coarse white lines (g).

Tip:
- Whichever method you use, white gouache (tinted to the correct colour) is extremely useful for touching up veins, here and there, in the final stages.

Stems and branches

These are important parts of a plant which, apart from holding it together, help to give it individuality and personality. Do not assume that all stems are round in cross-section – they can be oval, flat, quadrangular and so on; observe these features carefully to make sure you are painting a botanically correct study.

Forming tubular stems

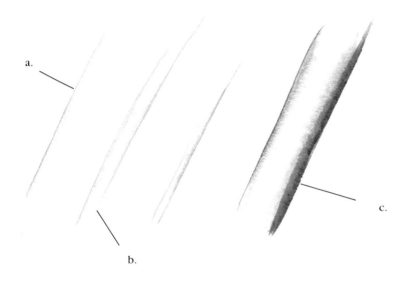

A thin line of green was stroked across the paper with a small brush for the left side of the stem and immediately another clean wet brush was stroked alongside to the right, pulling the colour into the clear water (a); to finish the process, a stripe of darker green was stroked alongside the water, merging it back into colour on the right side of the stem (b). Another stroke of water down the middle may be needed to blend it smoothly. A larger stem needs larger brushes (c). The first side can be allowed to dry before the second side is added if this is easier. Darker tones and hues can be carefully overlaid, if necessary, in the second stage.

Tip:

- Usually a stem will be broken into sections by leaves, flowers or other stems crossing in front; so you can work on a short section at one time. If you have a long, unbroken stem and do not feel confident enough to paint it in one long stretch just paint a shorter section, fading out the ends with a clean, wet brush; when this is dry, you can 'overlap' the next extension, also with faded out ends.

Woody stems or branches

These can be painted in much the same way but creating a more mottled and irregular shape in the first layer (d). Details are added and blended later to create texture (e).

Tendrils and roots

Even fine tendrils and roots have three-dimensional form, so make them look tubular, using very fine brushes. I rarely paint roots as I feel it is rather cruel to dig up plants and leave them dangling in air! But sometimes the roots may be of particular interest because they look unusual or are of nutritional or medicinal use, in which case botanists or scientists might like to see them in your painting.

Thorny stems

It is usually best to add thorns later as a final detail after the main stem has been formed; for finger-pricking thorns you need to attain the sharpest points (f).

Hairy stems

Hairs can be added singly with a very fine brush (g) or fine, fluffy hairs can be added 'en masse' by loading a larger brush with paint, flattening the head and stroking it over paper until there is the right amount of paint to form many fine, hairy lines at a time (h). White gouache can be used in the same way for pale or white hairs.

6 FRUIT: COLOUR AND FORM

The definition of a fruit is 'any structure on a plant that bears one or more ripe seeds'. They come in an enormous variety of shapes and forms, for example hazel nuts, holly berries, the two-winged 'samara' of an Acer, poppy capsules, dandelion clocks, tomatoes, apples, strawberries and pineapple. Capturing the form (three-dimensional shape) of a fruit is important if it is to look real, and good lighting on your subject will make it look more 'round'. Watercolour is the perfect medium to create the wonderful colours and textures that you find on the outer surfaces of fruit and the blending of hues and tones, wet in wet, on the paper can work to great effect when developing form. The inside of a fruit can also be very interesting and often extremely beautiful.

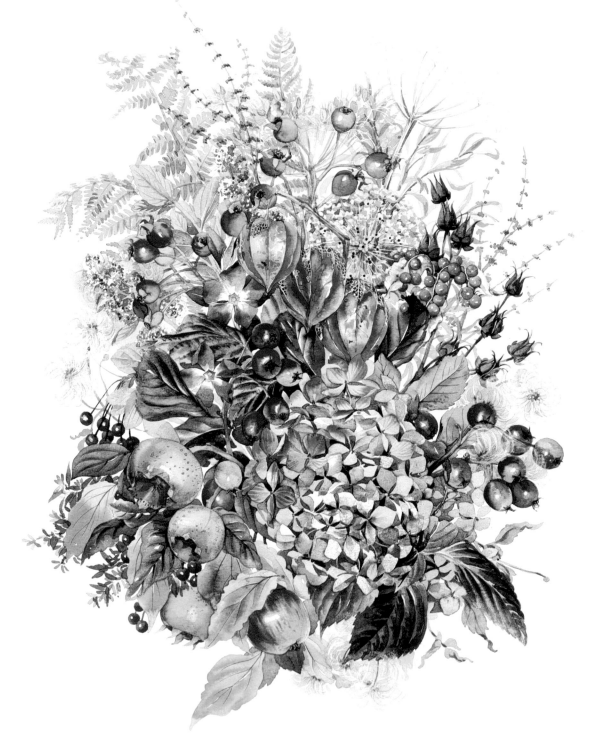

Soft fruit and berries

Ilex aquifolium 'Pyramidalis Fructu Luteo'

Berry colours: WL, TY, WYD, WO, FU
Leaf colours: WL, SG, FU, PG

This holly has unusual yellow
berries; as with yellow flower
petals, tonal variation is needed to
form the shapes but it is important
not to overdo the shadows or they
could end up looking dirty instead
of a clean, bright gold. Little
groups of berries can be painted
together in the first wet-in-wet
wash, then individual berries are
picked out by gently overlaying
stronger colours, softening and
blending where necessary.

Autumn Garden (opposite)

Colours: almost every colour in the paintbox

The purply blue of the hydrangea, periwinkle and
ceanothus flowers (being the complementary colour
of orange) spark off the autumn hues. Feathery ferns,
sorrel and Old Man's Beard soften the edges of the
composition.

Little Autumn Fruits

Colours: WL, NG, WO, BR, SL, PC, FU, WV, PG, SG.

Watercolour, and especially the wet-in-wet technique, was particularly effective in creating the rich colours and rounded forms of this selection of autumn fruits. Note the glossy highlights on the large *Rosa rugosa* hips and the soft highlights on the various *Malus* fruits.

A translucent blue wash was used to attain the soft bloom on the sloes and damsons, blending in richer hues wet in wet. My first book contains detailed information on painting berries.

Rubus fruticosus (Blackberries)

Fruit colours: WL, SL, PC, WV, PG
Foliage colours: WL, WYD, SG, FU, SL, PC

It took some time to find a perfect cluster
of blackberries. The main leaf, with its
interesting blemishes, was growing
elsewhere and I connected it to my
branch in the painting – one of the
advantages of working with paint
rather than photography!

1 The whole shape of each blackberry was painted with a watery Payne's Gray wash (leaving little spots of white paper for the highlights) and little blobs of more concentrated Payne's Gray were dotted in (wet in wet) with a small brush.
2 When this was dry, each distinct bobble was formed and blended with fine and small brushes.
3 The edges of some of the white highlights were carefully softened with a fine, damp brush and blotted with tissue.
4 The unripe, red berries were formed in the same way.
5 Leaves and stems were painted after the berries.
6 The little blemishes were among the final details.

Tips:

• Ready-mixed black watercolour paints seem to be rather 'dead'. Winsor & Newton's Payne's Gray is a rich blue-black that can be used on its own or mixed with other colours such as French Ultramarine, Winsor Violet and Permanent Carmine to make a variety of vibrant, rich blacks, especially suitable for all 'black' berries.
• Remember that small touches of colour (such as the little, soft, dark blobs on a blackberry) will not run too far into a wet wash on the paper if they are quite concentrated and touched in with a small brush – so that only a small amount of paint leaves the brush.
• Soft highlights can be lifted out by loosening pigment with a fine, wet brush and blotting with tissue.
• You cannot beat white paper for really bright, sparkly highlights but, if you have lost these during painting, little touches of pure white gouache (added at the end) are almost as effective.

Larger fruits

'Custard White' squash

Fruit colours: WL, FU + WO/BR (greys)
Flower colours: WL, WYD, WO, SG, FU
Leaf colours: WL, SG, FU, SL

My plant material for this painting was kindly supplied by a neighbour. I had to make several visits to their vegetable patch, taking a bit at a time, as the soft flowers and foliage wilted very quickly. I wanted to show the sprawling habit of the plant tumbling across the ground and thought about painting the earth beneath the creamy-white squash to show it up but decided that it would look better sitting on a leaf.

Vegetables, bulbs, fungi

Root vegetables such as carrots and turnips make interesting subjects when painted complete with leaves and/or flowers; there are countless varieties to choose from if you have a good source.

Peas and beans have great potential with their beautiful flowers, seed pods, shapely leaves and spiralling tendrils.

Bulbs, especially edible ones such as onions, with their papery, translucent skins and soft shine, can look fantastic in watercolour.

Fungi, with its abundance of forms, can also make an interesting subject though I have to admit it is not one of my favourites.
It usually looks better shown in its natural habitat surrounded by fallen leaves, bracken, moss and leaf mould.

Still life

Fruit and vegetables can look great in botanical studies just 'floating' on a white background, but they can also make stunning subjects in a still life. A little of the natural habitat around your subject can make a more interesting picture.

Castanea sativa (Sweet Chestnuts)

Colours: FU, WO, SL, LR, PC, PG, WL, SG

1 The pale, velvety lips of the open shell were painted first.
2 Next, the cluster of chestnuts within; the sun was shining on them, emphasizing the silky white highlights and the dark shadows. The rich colours of the chestnuts were blended wet in wet on the paper, leaving touches of white paper for the highlights.
3 The spiky shell was quite a challenge: a blurry, light olive wash with soft edges was laid down first. When dry, fine spikes of masking fluid were painted on and allowed to dry.
4 The large chestnut leaf was then painted freely, right over the masked spikes, and a medium olivey wash was stroked over the spiky shell, wet in wet.
5 The other leaves and scattered chestnuts were painted next and then the soft shadows underneath.
6 When all the paint was dry, the masking fluid was rubbed off and medium-toned rusts and greens worked into the rather crude, light spikes with a fine brush, followed by some really dark touches in the base of the spikes. I felt that I had overdone the darker tones and lost too many of the pale spikes so a few were put back with tinted gouache.
7 Finally some dry brushwork was used to strengthen the dark, chocolaty hues on the chestnuts and a few touches of white gouache lifted their silvery-white tips.

Bramleys and Blackberries

The still-life setting gives this painting, and the fruits within it, great depth. Although the fruit is realistically portrayed, some would think this is pushing the bounds of botanical art too far and would not class this as a botanical illustration or even botanical art, but rather as 'still life'. I have always found the bounds of 'botanical illustration' too restricting and like to vary my compositions and methods of portraying botanical subjects as much as possible.

After most of the hard work has been done and a three-dimensional watercolour image has been formed on the paper, it is the final details that really spark a painting into life and this is often the most rewarding stage. The large petals of this magnolia were painted relatively quickly using large brushes and watery washes, but it was the final details that really brought it to life. The fine veins on the petals were an important characteristic and the stamens and stigma, revealed in the gap between the petals, were essential details. The sepals enclosing the bud were covered with fine hairs, giving them a soft, downy texture, and there were tiny light spots on the pedicel that supports the bud. The branch behind needed touches of white gouache for the dusty bloom on its surface and little details to form the nodes, eyes and buds to give the branch its individual character.

Useful & time-saving techniques

Many details have to be put in very carefully using fine and small brushes, which can be very intensive, demanding a high level of concentration, brush control and patience. However, you can often find shortcuts – for example, there are ways of simulating textures without putting in every minute mark with countless, tiny brushstrokes.

- **Masking fluid** can be used to save little white or pale coloured details such as stamens, tiny white flowers or fine lines before painting. These little white shapes usually look rather coarse after the rubbery masking fluid has been removed, but they can be softened or refined to finish them off. The main drawback is that it has to be put down before painting begins, which is rather a clinical process, and your picture has to be well drafted in advance, which doesn't suit me as I like my paintings to flow and develop more naturally.

- **Gouache** – coloured gouache, white, or white tinted with watercolour – can be used to put in white or pale-coloured details such as stamens, highlights, veins or silvery hairs. It can also be dry brushstroked to give the impression of tiny, silvery hairs on a silky leaf or bud, or smudged to create texture like the russeting on apples.

- **Lifting** little areas of pigment (with a small, wet brush, then blotting with tissue) to lighten the tone and let the paper shine through can be very effective: for example, to simulate the little dots and blemishes on the skin of an apple, the tiny bulges on a primrose leaf or the bumpy texture of orange peel.

- **Dry brushstrokes** stroked over dry watercolours can add hairy, flocked or velvety texture or disguise messy paintwork. They can also be used to create rough texture and softened with a damp brush if the texture is too pronounced.

Magnolia campbellii var. mollicomata (detail) (opposite)
(The Shirley Sherwood Collection)

Flower centres

Although most details can be added towards the completion of a painting, it is important to observe them carefully before you start and consider how you are going to paint them as this may affect the formation of the painting. For example, when painting a flower that has pale stamens in the centre, little shapes of white paper may need to be saved right from the start. The carpel or pistil (which is the female organ of a flower) and the stamens (which are the male reproductive organs of a flower) are very important parts of a flower (see Appendix, page 124) and vary enormously between species. They are often the most problematical details to paint.

Hellebore flower – step by step

The easiest way to paint the pale stamens of this flower would be to paint the whole flower first and simply add them later with opaque gouache; but stamens always look sharper and more realistic if they have been there from the start rather than added as a superficial detail at the end. I decided to paint around the pale, stamen shapes with the petal colours, though some needed touching up with gouache.

Colours: WL, SG, PC, WV, PG

1 As the stamens were pale lemon and the petals were suffused with the same hue, a lemony wash was laid down over the central area of the flower, on wet paper, so that no hard edges formed as it dried.

2 Faint pencil marked the centre of the flower and the tips of the petals.

5 After the paint on the left petal was dry, the centre of the petal was wetted again and a pink wash painted carefully around the stamen shapes with a small brush – the colour instantly blending into the wet area.

4 This was repeated for the right edge and for the other petals, blending the colour with a clean brush where necessary.

3 The bottom petal was painted almost to the edge of the shape with water and immediately a pink edge was painted smoothly down the left side with a small brush, blending automatically into the wet shape.

6 The top two petals were painted in the same way.

7 Then the inner colours were carefully painted around the stamens, blending the colour softly into the wet petals, as before.

9 Stronger green details were painted into the cluster of stamens.

8 The detail was put in with small brushes. First, dark pink streaks and veins were added and softened.

11 Then the little curled, maroon, inner 'petals' around the stamens were painted; the little strips of shine are an important detail.

12 The dark, speckly, maroon blotches were added.

13 Finally the pale anthers and filaments were emphasized with tinted white gouache and the two distinct lobes of the anthers were defined.

10 The maroon stigma was next.

Lonicera 'Sweet Sue' (detail)

While forming the leaf shapes behind these long, straggly stamens, I left fine lines of white paper for some of the filaments and little gaps at their ends for the yellow anthers to be added later; it was difficult to paint around such fine shapes and several were lost – these were replaced at the end using gouache and a fine brush.

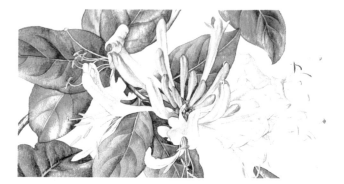

Red rose (detail)

A pale yellow wash was put down first in the centre of this rose and saved from the start. After the petals were completed, extra, individual yellow anthers were added, using gouache over the red; the red washes and the tiny dark details were the very last touch.

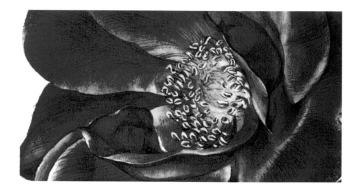

Field poppy (detail)

As these stamens were darker than the petals behind, it was easy to dot them over the petals at the end and a few touches of white gouache tinted with Payne's Gray lifted them and neatened up the top of the seed capsule.

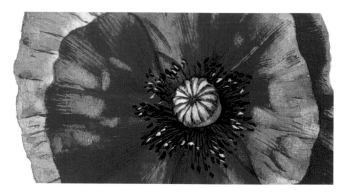

Scarlet lily (detail)

The centre of this flower was painted with pale tones in the first layer, using medium-size brushes, then the darker colour on the petal behind the filaments was carefully painted around the pale, thin filaments with a smaller brush and softened away to blend into the petal shape. The paler parts of the filaments were neatened up by lifting out the pigment after the petals were complete and dark red was stroked onto their fine tips. Dark little details like the anthers and dots on the petals are always the last to go in and really bring a plant to life.

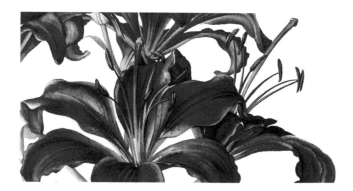

Tiny flowers

Tiny flowers, such as witch hazel or lilac, need even more precision if you are to fit all the details into such small shapes.

Hamamelis mollis 'Goldcrest' (detail)

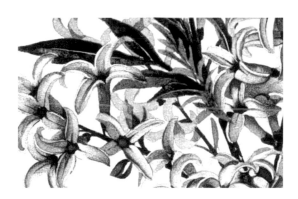

The colours were blended wet in wet, using small and fine brushes, to form the tiny ribbony petals of this witch-hazel; then the dark maroon sepals were added. When painting such fine detail, as with larger shapes, it is still important to achieve sharp contrasts between the tiny shapes to make them clear and distinct and not 'woolly'. This requires a steady hand, a good eye and lots of patience; if you do not possess these attributes, it may be better to concentrate on capturing the character of the plant in a slightly looser style and leave the finely detailed studies for those who are so inclined.

Syringa protolaciniata (detail)

Where you have a cluster of tiny flowers, as with this lilac, they can each be painted separately or, to speed up the process, they can be joined together (as a larger shape) in the first wash and then, when this is dry, each individual flower can be defined by working into the larger shape.

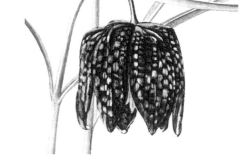

Markings on petals

Markings on petals are usually organic and irregular rather than neat, geometric shapes. Even dots on a lily petal will vary in size and shape and their colour may vary; do not be tempted to dot in the same size, shape and colour of dots without observing them carefully.

Fritillaria meleagris (detail)

I have seen many fritillaries painted with a coarse chequerboard effect quite unlike the wonderful irregular, merging pattern on the real flower petals. Here, the whole petals were painted first with translucent, pale washes to give the flower shape and form. Then the intricate markings were painted with fine brushes and softened and merged with a small, damp brush.

Pansy – step by step

Colour washes:

FU + WO, WL, FU + WV, WV + PR, WV + PC, WV + PC + PG, NG + WO.

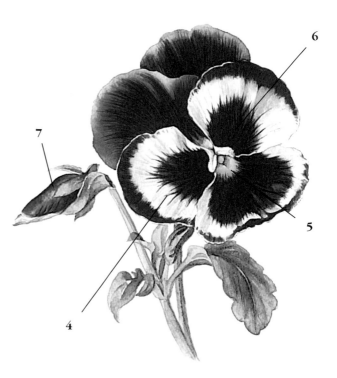

1 Touches of watery grey and lemon washes were laid down first.
2 Next, the magenta edge of a side petal was painted with a small (size 4) brush and a medium (size 6) clean, wet brush was quickly run alongside, pulling the wet colour towards the centre to blur the edge. This was repeated for the opposite petal.
3 Then the top left petal was painted in a watery mauve (size 6 brush) and a stronger purply wash was added wet in wet on the paper (size 4 brush), pulling the pool of colour down and along the bottom edge of the shape to form a contrast with the edge of the white side petal. When dry, the process was repeated for the other top petal.
4 Next, working on one side petal at a time, most of the white area was dampened with a wet brush (size 6) and fairly concentrated purples were carefully stroked in with a small (size 4) brush to form the dark blotches.
5 A strong yellow wash was added at the mouth of the bottom petal and drawn out with clean water;

strong purples were quickly stroked onto this damp area to begin to form the dark blotch.
6 Dry brushstrokes were used to build up the rich, velvety colour, especially on the dark blotches, and finally the dark veins and the central details were added with a fine brush (size 2).
7 Finally, the leaves and bud were painted.

Tips:
- Where you are trying to achieve blurred edges to dark blotches, the dark colour will be uncontrollable if the white petals are too wet.
 It will also be uncontrollable if the dark colour is too watery and not concentrated enough.
- Use small brushes to add soft details like the dark blotches – they hold less liquid so you can control the flow of colour onto the wet paper and it should not run too far.

Note: Brush sizes for this painting have been noted, in brackets, for your information.

Difficult details

Physalis alkekengi (Chinese Lantern)

Colours: WL, NG, WO, BR, SL, PC, SG, FU

Sometimes I look at a challenging subject and wonder how on earth to paint it; I haven't been completely stumped yet, though it can take a bit of thought and experimentation before I find the solution.

This almost perfect skeleton of a Chinese Lantern did pose some problems – the fragile network of veins was the colour of pale straw and although it would have been relatively easy to paint this complicated network on a white background with fine brushes, I felt that it would be much more effective to see the pale network set against darker tones. So I left fine gaps of paper for the main framework of the skeleton and some of the finer veins, painting the tiny, dark shapes in between with small brushes and watery colour washes. Many of the finest veins were added later with gouache.

To wash in the soft background grey around the lanterns, I brushed water outside them, before painting pale grey around the shapes and softly blending it into the wet paper. The little, dark holes on the lower lantern were among the last details to be added.

Analyses – dissections and cross sections

The vast diversity of flower structures, the shapes and forms of their components and their fruits, are fascinating and of particular interest to botanists. To study them, you need a sharp scalpel to dissect the parts of a flower and to cut neat cross sections, and tweezers to handle any miniscule parts. A ruler and a pair of dividers will also be needed to measure size and scale accurately. Good eyesight is sometimes adequate to examine them at life size but a strong magnifying glass (preferably the sort you can angle over your specimen) should enable you to see every tiny detail. A microscope is only needed for scientific illustrations.

Analytical studies can be:
- Either painted in watercolour, drawn with a fine pen and ink or drawn with a sharp pencil.
- Pen and ink drawings can be diagrammatic line drawings or tonal drawings (to make the subject look 3-dimensional); for shading, it is traditional to use fine lines, as in the Redouté engraving on page 14 (closer together or cross-hatched for the darker tones), or tiny dots (closer together for the darker tones).
- If illustrations are shown magnified, you should give the scale in relation to life-size (for example: × 2 if the illustration is twice life-size).
- A cross section of the whole flower or fruit is usually the most interesting and most important angle to show.

- If you illustrate individual parts as well, it will be more informative if you pencil a reference number or letter by each illustration and list the different parts, for example: 'A: calyx; B: petal; C: stamen; D: vertical cross section of carpel; E: horizontal cross section of ovary; F: cross section of stem'. If you annotate the painting, it is probably best to use neat, light, pencil handwriting so that it does not detract from the images.
- Analytical studies are often placed across the bottom of the picture or down the right-hand side but use your own sense of design to decide where to place them in your overall composition.

Primula vulgaris (Primrose) (opposite)

Colours: WL, TY, FU + WO (grey shadows), WYD, SG, FU

Of particular interest here were the differences between the internal structure of the 'thrum-eyed' flower (e) and the 'pin-eyed' flower (a). In some plants the stamens are at the top of the opening (thrum-eyed); in others the style is longer so that the little round stigma is revealed and the stamens are lower down the tube (pin-eyed). This ensures cross-pollination between different plants.

a. cross section of 'pin-eyed' flower
b. bud
c. calyx
d. cross section of calyx
e. cross section of 'thrum-eyed' flower

Before putting brush to paper, it is important to plan how and where to start painting and the sequence to follow. Botanical illustrations in this chapter are accompanied by detailed notes, step by step, through to completion; these bring together all the techniques and aspects covered in the previous chapters. Once the painting is completed, sympathetic presentation is important to maximize its potential and, if it is for sale, pricing can be tricky.

Flowers (and fruits) before foliage

Because oils, acrylics and gouache can all be used as opaque paints, you can put strong or dark colours down first and paint pale or bright colours over, to block out the dark colour beneath. For example, you could paint dark green holly leaves first and then paint pure, bright red berries with a white highlight over the leaves. Because watercolours are translucent, it is essential that you work in reverse by putting down the palest and brightest colours first (berries, in the case of the holly) building up to the darkest colours and tones, last. Flowers are almost always paler and/or brighter in colour than foliage, so it is therefore best to concentrate on painting them first. Also, cut flowers tend to have a shorter life than foliage, which can be added after the flowers have wilted.

Tip:

- There is another reason why it is unwise to paint in dark colours too early: if you have painted a dark green leaf, for example, and wish to paint a watery wash for a pale or brightly coloured flower petal alongside it, you will inevitably pull a little of the strong, water-soluble pigment from the leaf into your pale wash, dulling it down – even if the leaf is already dry.

Rosa 'Westerland' – step by step

One July morning I visited the gardens of a local rose-grower to choose one variety to paint. The choice (and the scent) was overwhelming and, as an artist, this blows my mind – I see dozens of gorgeous plants that I would dearly love to paint but I know that the petals will soon turn brown and crumple. However, you have to seize the moment and forget about tomorrow, choose one for now and hope there will be time to catch others later on. Having eventually decided on a variety, I walked round and round the bush trying to choose the best specimens to create an attractive composition. The buds of *Rosa* 'Westerland' were a bright orangey yellow that faded as the flowers matured and I needed a representative group. I was confident that wet-in-wet watercolour was the perfect way to blend the different yellow and peachy hues of these petals.

1 I started by visualizing the whole shape of the image on the paper, adjusting the flower stems until I felt happy with the arrangement, then holding them in position by wrapping long strips of sticky tape around the stems and attaching them to the top of the glass vase. I lightly sketched in the stems and the main flower shapes to check that it made an attractive composition on paper and to give me a rough guide to position and scale.

2 I decided to paint the right-hand, open bud first as it was in the forefront and I wanted to catch at least one flower at this stage while the colour was so intense. After mixing my main washes, I painted a yellowy wash in the central area, pulling it out to shape the edges of the petals and adding water to lighten the tone in places or blend it away to nothing. Quickly I stroked in touches of stronger orange with a small brush, wet in wet.

3 When this was dry, I worked into the shape, petal by petal, softening and blending as I went.

*Flower colour washes (Daler-Rowney except for Winsor &
Newton's Scarlet Lake, Winsor Orange and Payne's Gray):*

GH, WmO, WmO + SL, SL, FU + COH

Foliage colour washes:

FU, SG + WO, SG + FU + PG, AC + SG

4 Next I painted the top rose by wetting a large area, washing in yellows and blending away to nothing at the edges (a). A few touches of watery Scarlet Lake and French Ultramarine washes were added wet in wet, to start to form the edges of a few outer petals on one side of the rose (b).

5 With this flower, I felt it was best to put in the lower, foreground petals first and work upwards as the petals overlapped. I started to gently overlay some stronger shapes, forming contrasts between the individual petals; softening and blending away with a clean, wet brush (c). The strongest grey shadows and the stamens were added last.

6 Next I painted the bud nestling behind this rose and the other tight buds, completing one at a time as they were opening fast. I laid down the yellows and oranges, blending wet in wet on the paper (d); after this was dry I added the sepals, immediately giving them shape and form by varying the tones of green on the paper (e). When the first layer was dry I gently worked into the buds with small brushes, making them clear and sharp. Enough for the first day – but I could relax, knowing that, although every flower would have changed beyond recognition by the morning, I only needed one more fully open rose to survive until I painted it the next day.

7 I painted the lower, open flower in much the same way as the top one; by now it was fully mature and pale in colour and would probably drop petals at any moment! The flowers, being the most urgent and difficult part, were now completed and I felt much more relaxed about finishing the picture.

8 I worked on half a leaf at a time, using the central vein as a natural division. This enabled me to get some strong contrasts into the first, wet-in-wet layer of paint, giving the leaves much of their shape and form (f). Although the fine veins on the leaves were paler than the leaf colours, I decided to save only the central veins and 'lift' the others out later.

9 In the second stage I gently laid down darker strokes of colour to strengthen the colour and contrasts on the leaves, and softened them away where necessary with a wet brush (not too wet or it would lift and move the pigments below).

10 I neatened up some of the serrations, touched in some little dark veins and lifted the light ones with a fine, wet brush, blotting with a tissue.

11 Finally, I painted the stems with greenish tones first; a stroke of strong colour down the left side with a small brush, immediately running a stroke of water alongside to soften away the colour, and then a stroke of strong colour down the other side, against the dry paper, giving each stem an instant cylindrical form. Once dry, the darker, maroon tones were carefully overlaid to strengthen the stems and the tiny thorns were added.

Tips:

- Always prepare your main colour washes in advance – mix enough paint and test out the colours.
- As far as you can, work from the top down; so there is no wet paint beneath your hand or arm.
- Whenever possible, place a tissue or piece of paper beneath your painting hand – it could leave a greasy residue on the paper surface, which will repel watery washes.
- With a multi-petalled flower it would take far too long to draw in every petal before painting but it is easy to get 'lost' while painting petals. Before painting each flower, a few preliminary, light pencil lines to mark the width and height of the shape and a few 'landmarks' should help; try to keep your eye on the shape as a whole to make sure it does not go completely awry.
- Serrated leaf edges can be painted quite easily by repeatedly laying down the point of a brush, loaded with a wet wash, and quickly merging the little serrations into the whole shape. If you let them dry before merging, it will be difficult to blend them into the whole leaf.

a.

b.

c.

d.

e.

f.

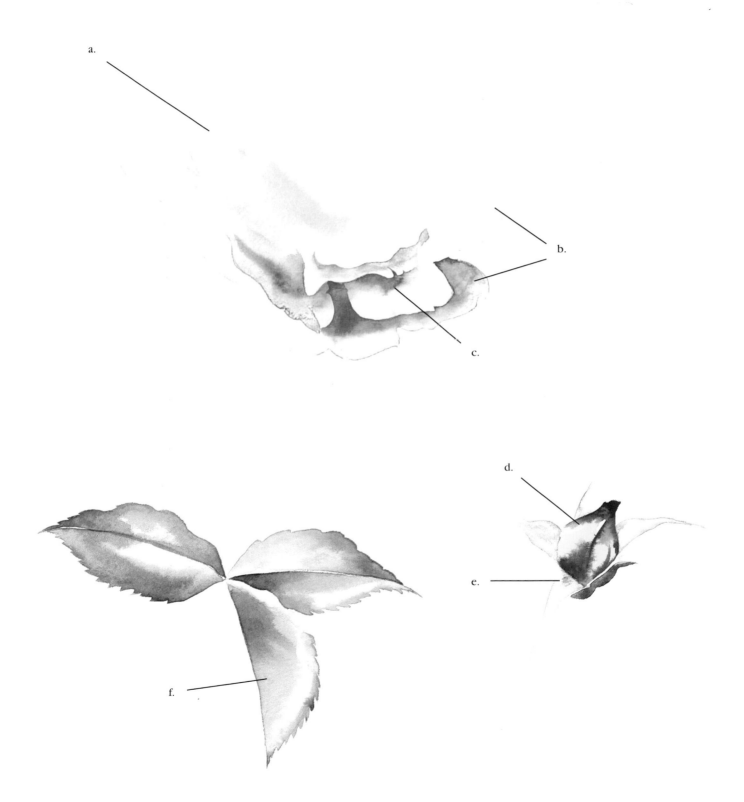

Rhododendron 'Fabia Tangerine' – step by step

I am fortunate in that some public gardens allow me to cut plant material to paint. Strolling among the spectacular rhododendrons, camellias and magnolias at the Sir Harold Hillier Gardens is a wonderful experience for most people, but for me, it is somewhat stressful – I feel almost panic-stricken that I have to choose just one! I was attracted to this particular rhododendron by the vibrant, coral-coloured flowers contrasting with shiny, bottle-green leaves. I made sure that I had a variety of buds, open flowers and a few of last year's dry seed-pods to show different stages in its life cycle. Looking at the bush, I made a mental note about the habit of the growing plant – how the umbels of open flowers nodded, swinging below and in front of the rosettes of leaves, whereas the buds were more erect.

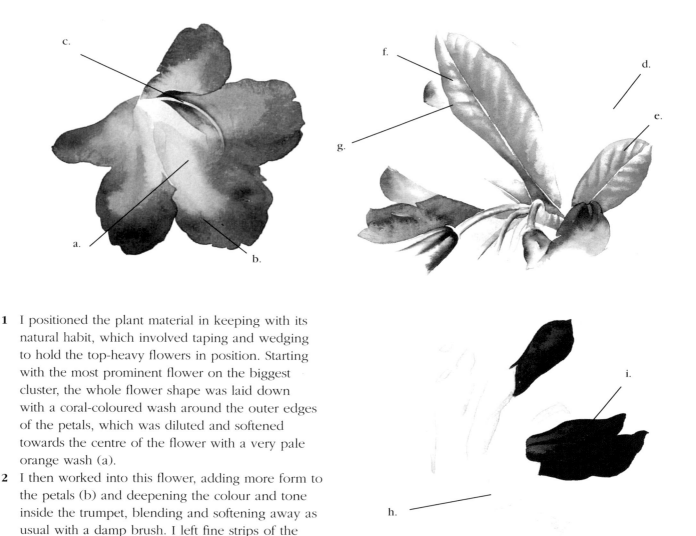

1 I positioned the plant material in keeping with its natural habit, which involved taping and wedging to hold the top-heavy flowers in position. Starting with the most prominent flower on the biggest cluster, the whole flower shape was laid down with a coral-coloured wash around the outer edges of the petals, which was diluted and softened towards the centre of the flower with a very pale orange wash (a).

2 I then worked into this flower, adding more form to the petals (b) and deepening the colour and tone inside the trumpet, blending and softening away as usual with a damp brush. I left fine strips of the first pale wash for the filaments and style (c).

3 As they were wilting fast, I decided to completely finish each flower one by one, adding the details of the veins, the speckled markings and the anthers.

4 The flowers towards the back of the clusters were the last to go in, along with the pale stalks or 'pedicels' of each flower. It took many hours to complete all the flowers and as I worked I

pencilled in some of the leaves to mark their position in case they too began to wilt before I got around to them (d).

5 I then began to paint the leaves, one at a time, working around and in between the flowers and their stalks (e). A great deal of form was achieved

Flower colour washes:

WO, SL, SL + PR, SL + PC + FU, PG + WV.

Foliage colour washes:

WL + WO + SG, SG, SG + FU, SG + FU + PG, SG + SL, SG + SL + PG.

by blending clear water, water with a hint of blue (f) and two different tones of green, all in the first layer (g).

6 Strokes of darker green were gently laid over the first layer on each leaf and softened away where necessary with a clean, wet (but not too wet) brush.

7 Where the pale back of a leaf showed, this was painted first and the dark green face of the leaf added later, when the back was dry.

8 After the main group of flowers and leaves were more or less complete, I added the budded stem behind, lightly sketching it in first to see if its position balanced the overall shape of the painting. The pale sepals were painted first (h). (Remember, you cannot paint over a strong colour with a pale, translucent wash but you can do vice versa). Then the rich-coloured buds were added (i).

9 Finally the main stems were painted and last details, such as the hairs on the flower stalks and the tiny touches of white gouache on the stamens, were added.

How long should it take?

After approximately three hours' preparation time (driving, walking in search of specimens, stretching paper, arranging plant material, testing colour washes, etc) I worked on the rhododendron painting for the remaining five hours of the first day, eight hours on each of the second and third days and about four hours on the fourth day (28 hours in total). It usually takes me somewhere between two and five days to complete a botanical illustration (according to its complexity and size), which is about the maximum time available when working from cut plant material. This is where the comparative speed of the wet-in-wet technique has great advantages over other, slower techniques. Of course there is much less time pressure if your subject is growing in a pot.

Stems and some additional details can be added after the flowers and leaves have died (a few pencil notes will remind you of these final touches) but you do need fresh leaves and flowers right there in front of you to observe the hues and tones, details and character properly. I never start a painting unless I know I have enough time ahead to complete the task. I rarely painted during my children's school holidays;

I soon realized that the frustration of seeing wilting flowers and an unfinished painting on my drawing board was just too stressful – for me and for them! Term times, with their structured days, were very productive but now my time is less structured and I seem to accomplish much less – I am more easily distracted by other tasks. Life can also throw in the odd crisis or diversion that needs your attention more than an unfinished painting; in which case some scribbled sketches, colour notes or photographs might save the day and you may be able to get fresh plant material to complete the painting later.

Tips:

- If you are unable to set aside long, uninterrupted periods and have to paint in odd snatched moments, try studies of single flowers or choose potted plants, especially those with long-lasting flowers like orchids, as these will give you much more time to complete the painting.
- It is always best to complete each component rather than leaving flowers or leaves half-painted to be finished later.

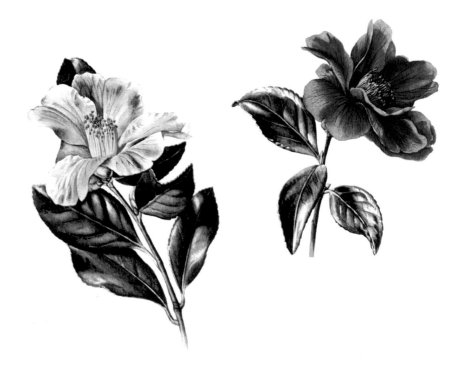

Presentation and pricing

Get the best out of your paintings by mounting and framing them professionally and sympathetically. The aim is to complement the image and let it speak for itself, not to fight with it or overpower it.

Tips:

- Avoid strong-coloured mounts as they invariably distract the eye from the actual image and often overpower it. Coloured mounts are often used for that very reason – to detract from a bad or unremarkable painting.
- Off-white is perhaps the safest mount colour and it can be made more special with a double mount (either the same colour or a different shade), or a line on the mount, or both.
- The same goes for frames; fairly neutral frames are usually safe and will fit any colour scheme and style of decoration. Watercolour flower/botanical paintings often look good in natural wood or a soft silvery-gold moulding (not a brash gold) or a moulding with a hint of green.
- Framing in a colour to match the flowers is risky – it will detract from the flowers in the painting and will limit your market.
- A really strong, bold subject may be able to stand something more dramatic.
- Use pencil marks to show your framer where to 'window' your image. The amount of space around it can be critical and they may get it wrong if you leave it up to them. Use mount corners as a guide (see Tips. page 106).

When it comes to the difficult task of pricing paintings, it is useful to keep a note of the time it took to complete each one. Much as I hate charging by the hour, as most other professionals do, you must bear in mind how much you should be earning for skilled, individual work and how many years of hard work and experience have developed that skill and talent – though you might price yourself out of the market if you charged what you really should!

Tips:

- I usually find it easiest to work back from the cost of the framed painting 'on the wall'; with experience you get to know what the market is likely to accept. Then I subtract the costs, such as framing, transporting to the exhibition, hanging fee and/or commission (often plus VAT) and so on. It is quite likely that you will only end up with about 50% of the 'on the wall' price. I divide the remainder by the number of hours it took and see if that is a realistic hourly rate. If it is not enough, then I must up the price.
- I really hate charging radically different prices according to where the painting is shown. For example, if your painting is in a prestigious gallery that takes 50% commission on sales, you really need to charge more than you do if you sell from home with no commission deducted. However, this is rather unfair to customers and I would advise trying to keep prices to a happy medium whereby you make less profit from the gallery sales (although you do get more exposure and publicity) and more profit if you sell from home.

Botanical illustrations don't have to be conventional, detailed studies of a single plant on a white background; this can of course look stunning, but there may be more exciting and less conventional compositions that could turn your subject into something really special. Although it is usually safer to opt for a conventional format, it is great to be adventurous at times and vary the design, scale and format of your illustrations. It is usually best if the overall shape of a painting – tall and narrow (portrait-shaped), wide and short (landscape-shaped), square, large, medium or small – reflects the character of the plant. The amount of space between components and around the whole image is also important. Shapes formed by the spaces between leaves and stems can be distracting – adding another stem, leaf or flower, to cut through a space, can often balance the design but it is easy to get carried away and overcrowd it.

Using space

Scarlet Lily

The simplest of all compositions – a single, vertical stem – suited this upright plant. With so many leaves spiralling down the stem, another stem behind or beside it would have over-complicated the image and the loss of space behind would have made it confusing. The foreground leaves were painted first, adding others behind these.

Tips:

- If the arrangement of plant material in front of you forms a pleasing shape, it should also look good on paper; take your time and rearrange specimens until you feel happy.

- If, when you are nearing completion, you are not happy with the design of a painting – for example, there might be a distracting line running through it, formed by stems or leaves, or it might look lopsided – adding another flower stem or leaf in just the right place may remove the distraction and balance the composition. Lightly pencil it in to see how it looks before painting, or sketch it on tracing paper and move this over the painting to find the best position. Then place the plant material at this angle, so you can observe it in this new position for painting.

- I often use sticky tape, wrapped around a stem and attached to the top of the vase, to hold it in position. Oasis is also useful, particularly if you have the branch or stem of a plant that droops or hangs, in which case you can anchor some soaked Oasis in a dish on top of a box so that the plant can dangle in front of you.

Strelitzia reginae
(Bird-of-paradise Flower)

These dramatic flowers needed very
little arrangement to form a stylish shape.
The streamlined petals and the large 'beaks',
with their soft, merging hues, were painted
with bold brush-strokes using the wet-in-wet
technique. Their large, shield-shaped leaves are
equally dramatic but I decided not to risk spoiling
the simple lines of the design by complicating the
picture and losing space.

Davidia involucrata
(Pocket Handkerchief Tree)

This spectacular tree is characterized by the drooping
'pocket handkerchiefs' of the mature, creamy-white
bracts that it bears in late spring; the younger
bracts are more lemony in colour. Its vivid green,
heart-shaped, serrated leaves are also notable and
the dark-chocolate clusters of tiny flowers, set against
the pale bracts, enhance its remarkable character.
I positioned the branch as if it were extending from
the tree so that the handkerchiefs hung naturally.

Iris sibirica

The long, graceful leaves of this
iris extended off the edge of
my full-sized sheet of paper.
The 'chopping-off' of leaves and
the windowing effect of a mount
tend to emphasize the shapes
that are formed between leaves
and stems. An extra leaf or two
can always be added to cut
through a distracting space.

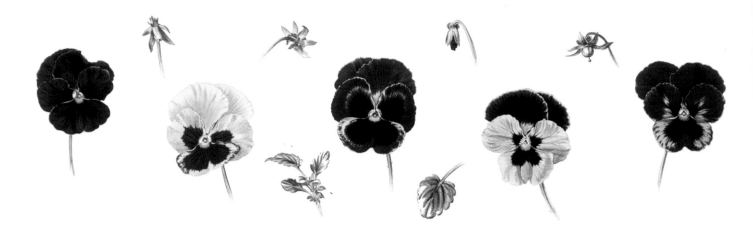

Row of Pansies (scarlet and gold)

I chose to use a horizontal composition for this row of pansies. I loved the comparison, side by side, of their different velvety 'faces'. Even with such strong colours, soft effects can still be achieved by blending colour washes, wet in wet, on the paper. The buds and fruits were important features of the plant and I decided to dot these between the flowers; they also interrupted the bland, white space around the flower shapes. Inconspicuous little buds, seed pods and leaves can look very interesting in carefully observed, detailed studies.

Tips:

- Two large corners of a mount are extremely useful when placed around the image (sliding them together or apart to adjust the size of the window). I always use these to look at my paintings and decide whether they are finished – distracting elements become more obvious. Simply cut diagonally through opposite corners of a large mount to make your corners.

- Working closely on a painting for many hours can make you very blinkered, so that it is difficult to see faults. At intervals, and especially when your painting is nearing completion, 'frame' it with your mounting corners. Place it upright on a table or chair, leave it for a while behind closed doors, then walk into the room and look at it with fresh eyes – this can be very revealing.

Group compositions

Oriental Spring (opposite)

It is usually best to paint plants life-size to give a true representation to the viewer. In this massed composition, the variety and contrasting scale of different species is immediately apparent. On the whole, the smaller 'dotted' flowers are placed round the edges to soften the shape of the image. I started with a group of two or three species, painted these, and worked outwards, gradually adding more plants around and behind them. Some of the foliage, which extended behind flowers that were yet to be added, had to be pencilled in and painted later. My aim was to paint as many different plants as I could on a full sheet of paper, to represent the opulent spring collection at the Sir Harold Hillier Gardens. Perhaps this was rather over-ambitious and maybe the painting suffers from lack of breathing space between the plants!

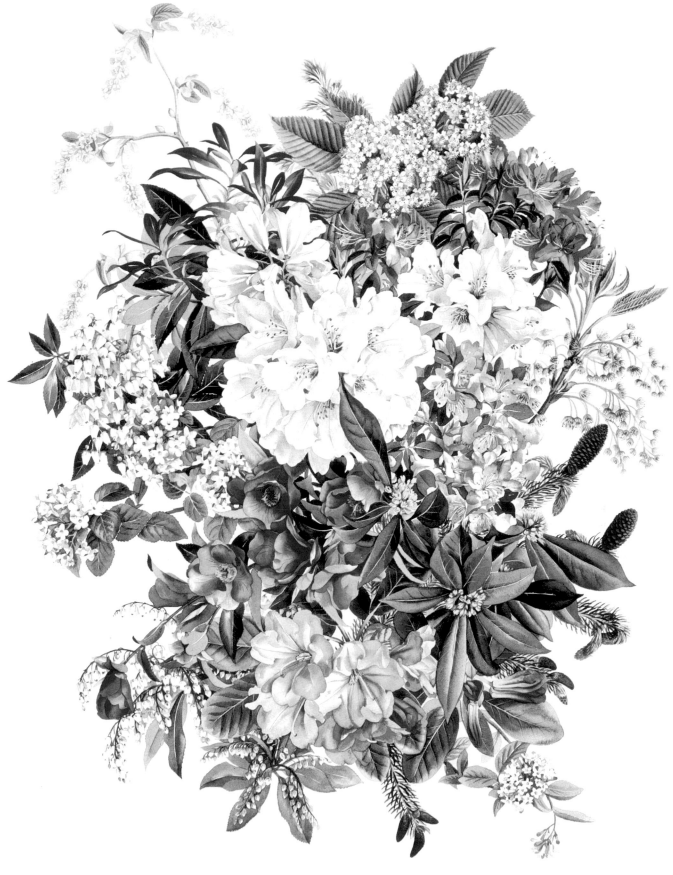

Parrot Tulips

A group of the same species of flower can be very effective and shows the flower head from different angles. Stem ends can be blended away softly with water, shown with cut ends or extended out of the painting – this is a matter of personal taste.

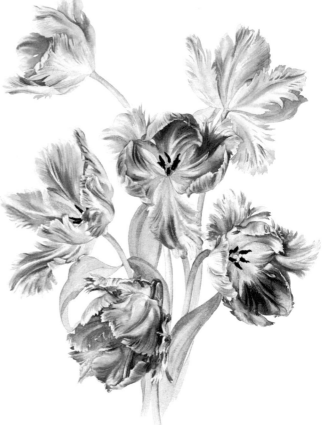

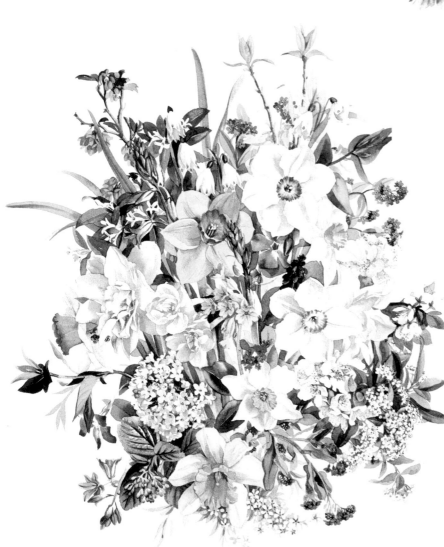

Spring Garden

A composition of many flowers or plants in one painting cannot be fully planned and drawn first, then painted later, as the flowers will have died before painting even begins. If you start in the central area, painting a single flower or a group of two or three (drawing them first if you need to), you can add others later, building your composition around the focal point. This painting is weighted towards the bottom, with the ends of the stems obscured by leaves and flowers. It is usually unwise to mix flowers whose colours clash horribly – the yellows, whites, oranges, blues and greens here complement each other.

Mixing pencil and watercolour

Combining pencil and painted images in one picture can serve a useful purpose and look attractive. For example, a painting of a flowering plant could be removed from the drawing board and put away until the plant is fruiting later in the year, when the fruits might be added with shaded pencil – or fruits painted in watercolour with flowers added later in pencil.

Passiflora molissima (below)

This passionflower was hanging among a chaotic tangle of its own creeping stems. I wanted to capture the habit and personality of the plant without confusing the picture and 'losing' the two featured stems, so I decided to do a faint, shaded, pencil drawing in the background.

Enkianthus deflexus (above)

I decided to use a simple pencil line to draw some of the leaves and the developing fruits; if I had painted more green leaves, they would have overpowered the delicate, nodding, bell-shaped flowers. I was also short of time to finish the painting!

Wild flower studies

Wild flowers are so wonderful it is hard to resist the urge to paint them, but a word of warning: you should never uproot plants without the landowner's permission and only pick a few of those that are plentiful, preferably on your own land as you could be accused of trespass by the landowner! Never pick or uproot plants growing in nature reserves and it is a criminal offence to remove plant material from endangered species. I suppose the best answer is to grow your own or work with the landowner – many are only too delighted to help a struggling artist.

Poppies and Harebells (top right)

These two species are made for each other: the complementary colours spark each other off, and the contrasting shapes and scale work well together.

Woodland Wild Flowers (opposite)

As these delicate, spring wild flowers were growing close together on the verge of a woodland path, I decided to paint them nestling beside one another as if growing together. Wild flowers droop quickly so I picked and painted one species at a time. This is another painting that might have benefited from more breathing space between plants.

Bluebells (bottom right)

The soft background flowers were added, after the detailed flowers were complete, to fill and balance the composition without confusing the eye.

Botanical 'still life'

Spring Flowers in a Blue Jug

Vases of flowers need some indication of a surface
to 'ground' them, as they look odd floating in
midair. The blue-grey washy background was
put in last and helped to throw the pale flowers
forward and give the painting depth. A looser,
more impressionistic style seems to suit vases of
flowers better.

Watercolour sketches

If you are painting in a garden or 'in the field' the conditions are rarely suitable to do a detailed, finished, botanical study. Quick, washy, watercolour sketches are great for capturing the colour, character and habit of a growing plant. The techniques used here are the same but executed with more speed and less accuracy than a botanical study. Because there wasn't time to add all the details, the freshness and spontaneity has not been lost. Many botanical artists (past and present) use watercolour sketches, together with drawings, notes and photographs, as reference material to enable them to complete the finished piece in the studio later.

Romneya trichocalyx
(Californian Tree Poppy)

The flowers were painted first (or rather, the shadows on the white petals) and outlines of the flowers were lightly pencilled in so that the background washes and leaves could be quickly and freely washed in around the white petals. The contrasting tone of this washy background throws the white flowers forward.

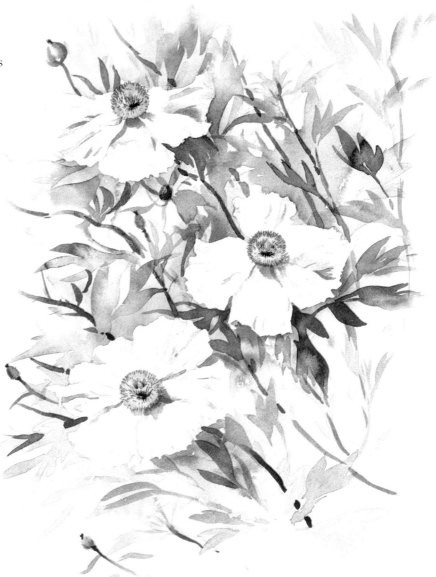

Composing botanical illustrations

There are an infinite number of configurations to use when deciding how to compose a botanical painting. The character and shape of the plant will often inspire a particular shape, size or format. Here are a few examples to get you thinking.

1. Single stem

2. Single species 'cut'

3. Single species growing (with ground)

4. Single species growing (with roots)

5. Single species growing (with growth point covered by foliage)

6. Mixed 'bouquet'

7. Mixed group composition

8. Separate studies on one page

9. Separate studies mounted together

10 Single species as
if growing (stems
ending within picture)

11. Single species as if
growing (extending
outside picture)

12. Single branch as
if growing

13. Close-up

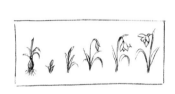

14. Plants in habitat

15. Plants in habitat
(with background
surroundings)

16. Studies of growth and
development

17 Still life (e.g.
with vase)

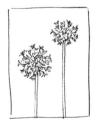

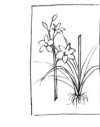

18. Tall plant (omitting
leaves)

19. Tall plant
(with leaf tips)

20. Tall plant 'chopped'
(with lower section
alongside)

21. Botanical study
with analyses
(across base of
painting)

22. Botanical study
of a tree with
analyses

Before you even begin to consider how you are going to execute your painting, you may have a few problems to solve: where to obtain a particular plant; how to reach and cut high specimens; how to hold plant material in position; how to keep it alive; and how to do it justice. In this chapter, paintings of plants, each one with its own particular challenges, are accompanied by personal anecdotes that may help with some of the practical problems we botanical artists encounter. My first book contains more information and tips on working as a botanical artist.

Practical problems

Paeonia suffruticosa 'Joseph Rock' [Mark One] (The Shirley Sherwood Collection)

It is difficult to do justice to really spectacular plants – to capture their sheer splendour on paper. Over a two-year period I worked on a collection of paintings for an exhibition at the Royal Botanic Gardens, Kew. During this time I was given access to the many fabulous plants growing at the Sir Harold Hillier

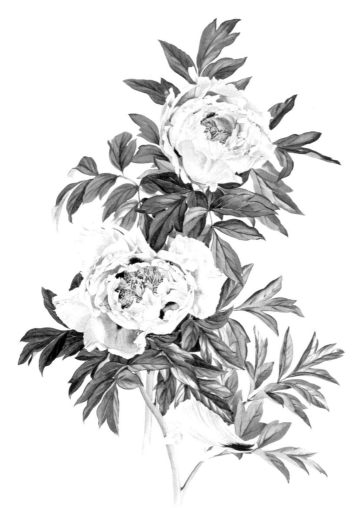

Gardens and I had a phone call one day from the curator to tell me that this magnificent paeony was in full flower and it was a must for the Kew exhibition. There was, however, a slight drawback – it was Whitsun bank holiday weekend and my children were on holiday from school.

I marched through the gardens, small daughters in tow, up to this magnificent plant, which was growing in the heart of the garden by a busy pathway; to the gasps of onlookers, I snipped a leafy stem topped by a huge white flower with my secateurs and hurried my daughters back to the car park as quickly as possible, fully expecting to be arrested! My mother-in-law was enlisted to entertain the children while I set to work. I hadn't dared to remove more than one flower so I had chosen a half-open one, hoping it would open fully indoors. Like Frank Round with his irises, I painted it once (at the top) and then again underneath although, frustratingly, it never fully opened. I knew they looked even more spectacular when fully open and, although the painting turned out quite well, I felt I had not done it justice.

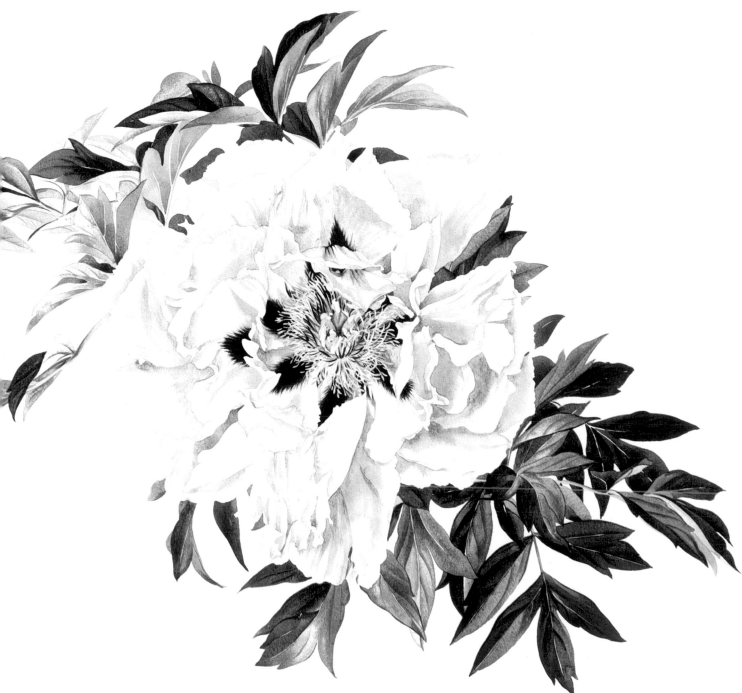

Paeonia suffruticosa
'Joseph Rock' [Mark Two]

I mentioned my disappointment to the curator who insisted that I take another paeony and try again. This time I took a large, fully open flower and painted it 'head on', looking down into its heart, surrounded by a rosette of leaves. I felt happier with the result although, like many artists, I always think I could have done better.

Cornus 'Norman Haddon' (right)

I decided to paint this rather late in the summer and
the freshest flowers were out of reach on the beautiful,
spreading tree; a gardener with a tractor kindly
volunteered to raise himself up high on his front
loader, armed with long-handled cutters – I caught
the cut stem as it fell. Where there's a will, there's a
way! The flower heads are made up of bracts (not
petals) which surround tiny, insignificant flowers. The
creamy bracts turn to deep pink in summer and these
are followed by attractive, strawberry-like fruits.

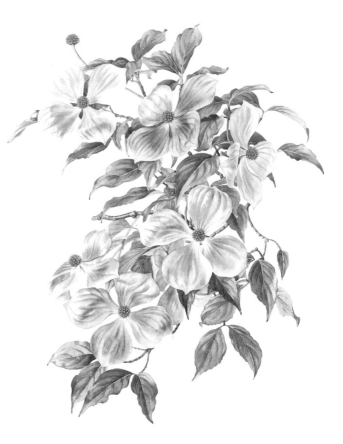

Lonicera 'Sweet Sue' (below)

This beautifully scented honeysuckle was discovered
growing wild on a beach in Sweden by Roy Lancaster
and named after his wife. I was asked to paint it in
late October and had to use three rather sparse plants
in pots to gather enough flowering material to cobble
together so that it looked like one plant – such are the
trials of the botanical artist!

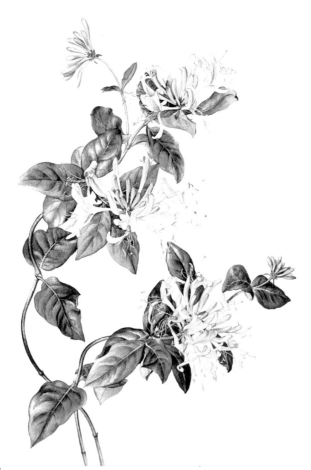

Digitalis 'Saltwood Summer' (right)

I was asked to paint this exciting new foxglove and
provided with a specimen growing in a pot. The spires
were taller than me, which caused a few problems. If I
had cut the stem to bring the flower spike down to
eye level, it would soon have wilted and I knew I
would need many days to complete this one stem. As
the weather was good, I decided to paint it outside
and rigged up a platform to raise my chair and easel
so that the huge flower spike was nearer my eye level.
It took a few days to complete the main stem and the
budded tip; the weather had gradually deteriorated and
annoying strong winds were buffeting the plant so I
admitted defeat and withdrew to the studio to
complete the painting. I had to chop off the flower
head before lifting the plant onto my table. The light
had of course changed, giving different hues to the
foliage, so I decided to use pencil to portray the lower
section of the stem (right) and added another stem
(left), to balance the composition. The flowers were
now over and the pencil also served to differentiate
the plant at the next stage of development.

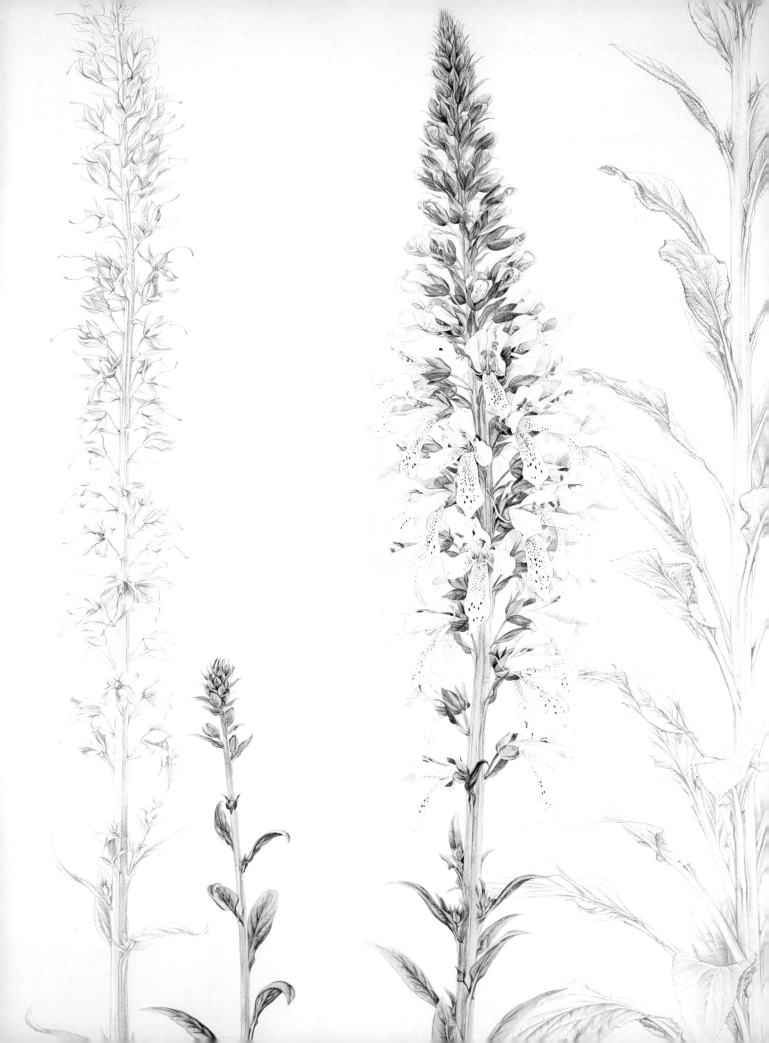

Agapanthus praecox

I was commissioned to paint an agapanthus
rather late in the season but was unable to find
any still in flower until I approached Hilliers
Nursery, who lent me this wonderful specimen
in a pot. The flower stems were over four feet
tall – much too high to observe closely when
placed on my desk. I stood the pot on the floor,
so that the flowers were near my eye level, and
sat at an easel with my huge drawing board
precariously balanced at a 45° angle. When I
returned the magnificent plant intact to the nursery
manager, I mentioned my difficulties; he asked me
why I hadn't just cut the stem and put it in water –
it was the end of the flowering season and the flower
heads would soon have been removed anyway! I was
also faced with the perennial problem when painting a
plant that has a long stem – if you cannot fit the whole
plant on a large sheet of paper, do
you paint the base of the plant
alongside the flower stem
showing the stem as if it
was cut, show the tips of
the leaves just
appearing at the
bottom of the
painting, or omit the
leaves completely
and concentrate
on the flowers? I
decided on the last
option in this case
as the flower heads
made such a bold
statement on their own.

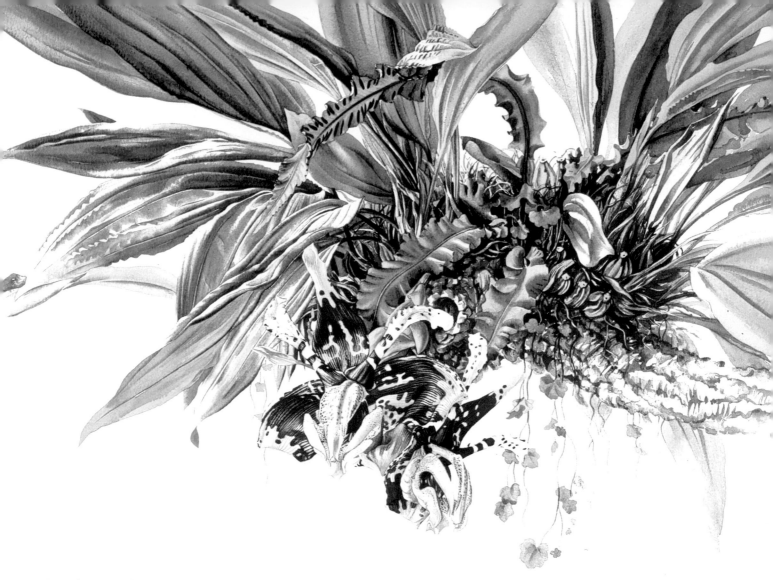

Stanhopea tigrina

I spent much of one year at Wyld Court Rainforest in Berkshire (now called 'The Living Rainforest') painting tropical rainforest plants. The round trip from my home was about 90 miles and I often drove up in icy conditions only to strip off most of my layers before entering this lush exotic jungle in the tropical heat and humidity of temperature-controlled glasshouses. The temperature was often over 32°C (90°F). Sometimes, I managed to position myself close enough to sit and paint the growing plants at an easel. Others were in pots and I was able to move them to a cooler greenhouse to paint in private, away from curious visitors.

One day the curator mentioned that this particular orchid, which flowered quite infrequently, was about to bloom – the flower lasting only a day before it

withered. I cannot resist a challenge and, as it was growing in a slatted basket, he allowed me to take it home as I would have more time to concentrate on it. I used a bit of artistic licence and painted it sitting on a branch as it would in the wild, being an epiphyte; I borrowed the branch too. I should really have checked whether the intermingled fern and trailing toadflax, also growing in the basket, were suitable companions but I liked the mixture.

Apart from the pressure of completing the flowers before they died (the back flower, as you can see, was already on its way out), my husband and I had to put up with its overpowering, sweet, sickly scent in our bedroom (as this was also my 'studio'); in the middle of the night I could stand it no longer and shut it away in another room.

Magnolia campbellii var. mollicomata
(The Shirley Sherwood Collection)

The sight of these huge, pale pink, cup-and-saucer-shaped flowers on a tall, leafless tree against a bright blue sky in early spring is truly spectacular. I had to seek assistance to reach a branch using long-handled cutters and a ladder. Back at home, my next problem was how to hold the top-heavy stems in place; I managed this by wedging, propping and taping them in a large glass bowl. I lightly sketched in the position of the branch and a large circle for each flower to form a graceful composition. I painted the left-hand flower straight away and then turned it and painted it again (at the top) when it had opened a little more. Then I painted the large open flower before putting in the branch behind.

Hibiscus rosa sinensis 'Casablanca'

This spectacular white hibiscus was painted during the summer at Wyld Court; the temperature was so oppressive that I dashed off a really quick, free watercolour. Large brushes were loaded with very wet washes and blended wet in wet on the paper – basically the same technique that I use in even the most accurate, detailed botanical study, but this painting was finished in about two hours. Quick watercolour sketches really concentrate the mind and force you to capture the essential characteristics of a plant, in the manner that Walter Hood Fitch and Frank Harold Round excelled, without being waylaid by finicky, superfluous detail.

The working artist

Such are the trials and tribulations of the botanical artist! My little foray into the 'rainforest' was nothing when compared to intrepid artists such as Ferdinand Bauer who spent five years of his life on a trip to Australia to paint plants; or Marianne North who travelled all over the world in the 19th century, recording spectacular plants with oil paints in their natural surroundings; or Margaret Mee, whose passion for tropical, endangered species took her deep into the Amazon rainforests. The troubles they must have had – and what enthusiasm and determination to overcome their difficulties and produce so many incredible and significant works of art for posterity!

I began Chapter 2 with these words: 'Creating stunning botanical paintings with complete self-confidence in peaceful, comfortable surroundings sounds the perfect way to spend your days. We botanical artists should be the luckiest people in the world!' I think I have proved that our occupation, like any other, has its ups and downs and can, on occasions, be somewhat stressful. However, there is great pleasure in experiencing, studying and portraying the wonderful and diverse world of plants – and if you can make your living by selling and sharing the products of these experiences, that is a real bonus.

Basic botany

As long as you understand the basic structure of plants, especially the flowers, and carefully observe the way each one fits together and the particular characteristics of each part (leaves, stems, fruits and parts of the flower), you really cannot go wrong.

The parts of a flower

- The **corolla,** which is usually the most showy, colourful part of a flower, is made up of varying numbers of **petals**.

- The **calyx** (plural **calyces**) is the outer, protective part of a flower, formed of **sepals**.

- The calyx sits on a **pedicel,** which is the stalk of the individual flower.

- The **carpel** or **pistil** is the female reproductive organ of a flower consisting of a **stigma, style** and **ovary** (which contains seeds).

- The **stamens,** which are the male reproductive organs of a flower, each consist of a **filament** topped by an **anther** (which usually has two lobes and contains pollen grains).

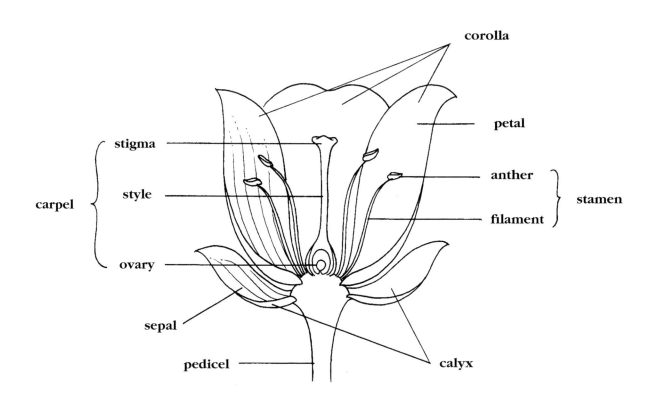

Botanical names

It is always informative for the viewer to see plant names (Latin and/or common names) neatly written beneath a plant study, but, unless you have attractive informal handwriting (which can look good in pencil) or you can write a perfect script (using pencil, pen or with a fine brush), it is probably best not to write plant names directly on your paintings; it can ruin a good painting and be very distracting if it is not done well. Whether you put the name on the actual picture, beneath the painting, on the back of it or in a catalogue, always ensure that you have the correct botanical spelling and nomenclature (with upper- and lower-case letters and italics used correctly); the way a plant name is written gives important information to a botanist or horticulturalist.

Here is a brief guide:

- Each plant belongs to a **family**, usually a group of similar genera (plural of genus); most of these end in –aceae, such as *Ranunculaceae* (the buttercup family) plus a few with other endings such as *Compositae* (the daisy family). This family name is not usually written down when naming a plant.
- The Swedish botanist Carl Linnaeus drew up the Binomial System of Classification (c. 1750) giving all plant species a name consisting of two words; the first word refers to the **genus** and the second to the **species**.
- The **genus** is a subordinate group to the **family** and covers a group of one or more related species such as *Rhododendron, Rosa, Camellia* or *Chrysanthemum*. This generic name forms the first part of the binomial name.
- The **species** is subordinate to the genus and represents a group of individuals that are closely related and mutually fertile, such as *sasanqua, japonica* or *saluenensis,* which are different species of the genus *Camellia*; this forms the second part of the binomial name.
- Species may be divided into **subspecies** (subsp.), **varieties** (var.) and **forma** (f.), which are subdivisions of species used to distinguish different groups or distinct variants within a species.
- **Cultivars** are varieties or strains produced and cultivated by horticulturalists and are not normally found in the natural plant kingdom. They are given a 'fancy name' such as *Rosa rugosa* 'Frau Dagmar Hartopp' or *Magnolia liliiflora* 'Nigra'.

- A **hybrid** can be a cross between two species, within the same genus, in which case it is given a new Latin name written with a cross in front; for example, *Camellia × williamsii* is a hybrid between *C. saluenensis* and *C. japonica*. There are many different cultivars of this hybrid such as *C. × williamsii* 'Caerhays' or *C. × williamsii* 'Donation', which have been given different fancy names.
- A **hybrid** can also be produced from two cultivars within the same species in which case the hybrid (×) sign is dropped; for example, many roses, such as *Rosa* 'Queen Elizabeth', have been crossed between cultivars.

Botanical names should be written as follows:

- Genus and species names should be in Latin with a capital first letter for the genus, eg: ***Rosa** gallica*.
- Hybrid names, where species have been crossed, should be in Latin with a small first letter and a cross in front, eg: *Magnolia* × ***soulangiana***.
- Hybrid names, where cultivars have been crossed, should not have a '×' sign, should be in single quotes, not italics and initial letters should be capitals, eg: *Viola* **'Oxford Blue'**.
- Cultivar names should be in single quotes, not italics and initial letters should be capitals, eg: *Galanthus nivalis* **'Flore Pleno'**.
- In handwritten text, words that would appear in italics should be underlined instead.
- Common names such as 'buttercup' or 'primrose' are not written in italics.

Useful Addresses

The Living Rainforest
Hampstead Norreys, near Newbury
Berkshire RG18 0TN
Tel: 01635 202444
Web: www.livingrainforest.org

Sir Harold Hillier Gardens
Jermyns Lane, Ampfield
Romsey, Hampshire SO51 0QA
Tel: 01794 368 787
Email: info@hilliergardens.org.uk
Web: www.hilliergardens.org.uk

Mottisfont Abbey Garden (The National Trust)
Mottisfont, Romsey, Hampshire SO51 0LP
Tel: 01794 340757
Email: mottisfontabbey@nationaltrust.org.uk
Web: www.nationaltrust.org.uk

The Society of Botanical Artists
Pamela Henderson (Executive Secretary)
1 Knapp Cottages, Wyke, Gillingham
Dorset SP8 4NQ
Tel: 01747 825718
Email: pam@soc-botanical-artists.org
Web: www.soc-botanical-artists.org

The Lindley Library
Royal Horticultural Society
80 Vincent Square
London SW1P 2PE
Tel: 020 7834 4333
Email: library.london@rhs.org.uk
www.rhs.co.uk

The Royal Botanic Gardens
Kew, Richmond
Surrey TW9 3AE
Tel: 020 8332 5000
www.rbgkew.org.uk

Bibliography

Blamey, Marjorie, and Christopher Grey-Wilson. *The Illustrated Flora of Britain and Northern Ireland*. Hodder and Stoughton, 1989.

Blunt, Wilfrid and William T Stearn. *The Art of Botanical Illustration*. The Antique Collectors' Club, 1994.

Brunfels, Otto. *Herbarium Vivae Eicones*, 1530. (Kew Gardens copy)

de Bray, Lys. *The Art of Botanical Illustration*. Christopher Helm, 1989.

Dioscorides Codex vindobonensis (Medicus Graecus I), c. 512 AD. Facsimile published by Akademische Druck-u. Verlagsanatalt, Graz, 1965–70.

Emboden, William A. *Leonardo da Vinci on Plants and Gardens*. Christopher Helm.

Hickey, Michael. *Plant Names: A Guide for Botanical Artists*. Cedar Publications, 1993.

Mayo, Simon. *Margaret Mee's Amazon*. Royal Botanic Gardens, Kew, 1988.

Michaux, André. *Histoire des Chênes de l'Amerique septentrionale, 1801* (W J Hooker's copy, Kew Gardens).

Morrison, Tony (ed.) *Margaret Mee: In Search of Flowers of the Amazon Forests*. Nonesuch Expeditions.

Reader's Digest. *The Reader's Digest Encyclopedia of Garden Plants and Flowers*. Reader's Digest, 1987.

Royal Horticultural Society, The. *Gardeners' Encyclopedia of Plants and Flowers*. Dorling Kindersley.

Rytz, Professor Walther. *Pflanzenaquarelle des Hans Weiditz aus dem Jahre 1529*. Bern, 1936.

Tomasi, Lucia Tongiori (curated by). *I ritratti di piante di Jacopo Ligozzi*. Industrie Grafiche Pacini, Pisa.

Index

Page numbers in bold denote the main article or illustration. Page numbers in italics denote illustrations. Plant names, illustrations and book titles are in italics.